TACOMA
CURIOSITIES

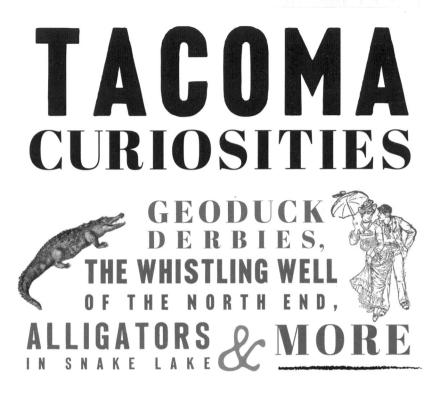

GEODUCK
DERBIES,
THE WHISTLING WELL
OF THE NORTH END,
ALLIGATORS & MORE
IN SNAKE LAKE

KARLA STOVER

THE
History
PRESS

Published by The History Press
Charleston, SC
www.historypress.net

First published 2016

Manufactured in the United States

ISBN 978.1.46713.553.5

Library of Congress Control Number: 2016934221

It was a time when dreams came true,
the dreams of those old-timers and true believers like Carr and McCarver
who looked at the bay in the forest and saw a city.
—Murray Morgan

CONTENTS

PART 1. THE LAST OF THE PIONEER YEARS
Tackling Pacific Avenue 9
The First Aroma of Tacoma: A Much-Needed Sewer System 16
Soda Works 19
First Central School 22
Alpha Opera House 27
When Stomachs Rose and Fell with the Tide: Oysters 30
Recreation 33
The Flickers 39
Harry Morgan and the Theater Comique 43

PART 2. GROWING PAINS
Fifty Years of Houseboat Living 47
Olympus Hotel 53
Plagues and Pestilence Houses 56
Weather, Wells and One Big Hole 61
When Stomachs Rose and Fell with the Tide: Geoducks 65
The Gravel Pirate: C.D. Elmore Dishes the Dirt 68
Entrepreneurs 70
The Klondike Gold Rush Spells Doom for Tacoma 75

PART 3. A NEW CENTURY
Don't Knock It: Door-to-Door Salesmen 82

Alligators in Snake Lake and Some Other Snake Lake Trivia 87
Smuggling, Drugs and Demon Rum 89
How Much Would You Be Willing to Pay? 97
When Stomachs Rose and Fell with the Tide: Salmon—Eggs? 101
Trains and "Taters" 103
Camouflage, Camouflage Artist and a Little about Cereal 106
Smileage Books, Pneumonia Jackets and Tube Socks 110
A Reader Board and a Megaphone at Ledger Square 114

PART 4. STALEMATE: THE DEPRESSION YEARS
Ships No One Wanted: The Foundation Company 118
Depression Homes: Tacoma's Hooverville 122
Depression Clothes: Chicken Linen 126
Depression Income: Frog Farms 129
Depression Income: Flower Flour Power 131
The Depression-Mobile, Kitcheneering and More Homeless Men 135
And the Things They Left Behind 138

Bibliography 141
About the Author 143

Opposite: The Old Totem Pole, postcard circa 1903. *Tacoma Public Library Photography Archive.*

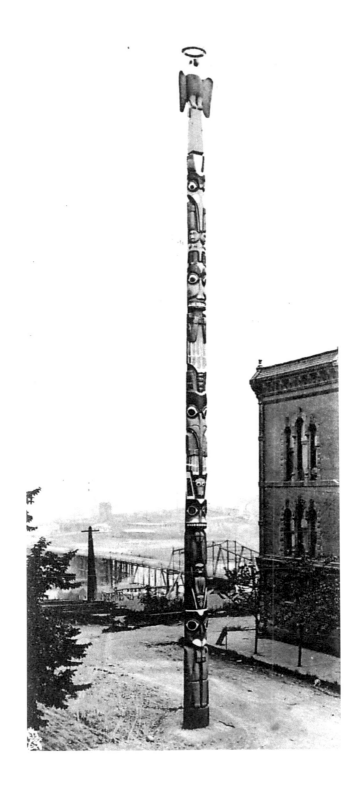

THE LAST OF THE PIONEER YEARS

TACKLING PACIFIC AVENUE

Considerable difficulty is being experienced in the construction of the sidewalk on part of Pacific Avenue. In some places the walk is built over the edge of the roadway necessitating the construction of trestle work thirty feet high in places.
–Tacoma Daily Ledger, *September 27, 1883*

Sometime in the 1870s, a man named Arthur Locke decided to follow the Northern Pacific surveying lines from his Spanaway Lake home to Commencement Bay because though he'd heard about the bay, he hadn't seen it. Locke tracked the stakes through the forest, walked down what is now Pacific Avenue and ended up at a tent built around a tree stump where Old City Hall is. The tent was a restaurant, so he ate dinner and walked back home.

Not long after that, James Tilton, Washington Territory's first surveyor general, was asked to plat a town. For "a salary of $300 a month, currency," he laid out one-hundred-foot-wide streets in the business district and forty-foot-wide residential streets. However, city fathers weren't happy with Tilton's ideas for draining Tacoma's clay bank hill, and his employment was short-lived. Army Corps of Engineers assistant engineer Colonel William Isaac Smith was asked to weigh in. He was in the area, working on Pacific Railroad surveys and explorations along the southern route of a proposed transcontinental railway route. Smith surveyed and re-platted. From the railroad terminal where the

> Many of the stores were perched high. Some were on a level with the sidewalks while others were below. The walks themselves were not level. The pedestrian must have a care where he stepped; night travel was precarious, and not safe without a lantern.
>
> —Herbert Hunt

wheat grain elevators are to the top of the bluff at Eighth Street and Pacific Avenue, volunteers graded an eighty-foot-wide road that residents called either Picnic Road or the Magnificent Drive. It wasn't very magnificent, however. The problem was that Pacific Avenue was a dirt road, therefore either muddy or dusty. For a number of years and at regular intervals, Chinese laborers were hired to wheel in barrels of gravel and spread it on the road.

By the 1880s, neither residents nor developers knew whether New Tacoma's business district was growing north or south. (Old Tacoma, aka Old Town, and New Tacoma merged on January 1, 1884.) The projected construction of a grand railroad station near Ninth Street was shelved. Instead, a modest wooden depot went up at Seventeenth Street. When people arrived, they either went north to the new Northern Pacific Building or the Tacoma Hotel or south into the small commercial district with its wholesale establishments, blue-collar boardinghouses and piecework businesses. Whether north or south, though, Pacific Avenue was unsafe because of poor lighting and the state of its roads and sidewalks.

When the first streetlights were installed, they used coal oil, and Marshal E.O. Fulmer had to light them at night and douse them in the morning. The presence of streetlights was so important, though, when the city added new ones, charges of favoritism about their locations were made.

In May 1884, an ordinance allowing for the illumination of Pacific Avenue by electric lighting was postponed. Instead, the city fathers directed their attention to the inspection and regulation of chimney flues. Two years passed before Tacoma Light and Water Company was ready to launch itself into the street-lighting business. The first electric streetlights went into service on December 26, 1886, along a three-quarter-mile stretch of Pacific Avenue. What the lights did was illuminate the shoddy state of Tacoma's roads. A typical news items was one like this: "On Thursday night a drunken man and a Chinaman were involved in a fist fight near the Railroad House and while in the thickest of the conflict, fell from the walk into the deep mud of the adjoining gutter and

were almost lost from view. They emerged from the soft slime with their ardor entirely cooled."

During circus parades, while dogs barked from rooftops, wagons regularly mired down in the streetcar rails. Skunk cabbages grew in the in the moist soil, and people crossed Pacific by jumping from one piece of driftwood to another. Comments such as, "Give us anything but mud," "Give us the first pavement that can be laid down" and "The council should have done something long before this," reached the ears of the city councilmembers. Clearly, a solution was needed, and the first remedy tried was laying planks. Property owners were assessed, and the work began.

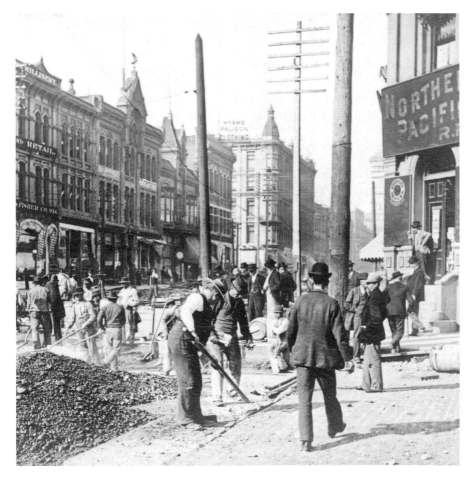

Fourth and Pacific Avenues after the "Tent Period," circa 1880. *Library of Congress, Prints & Photographs Division [LC-USZ62-101072 (b&w film copy neg.)].*

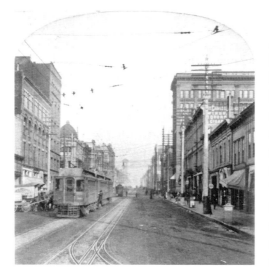

Pacific Avenue, 1904. *Library of Congress, Prints & Photographs Division, [LC-USZ6-174].*

How extensively Pacific Avenue was covered with planks isn't known, but they ran south at least as far as the Jefferson Street intersection. The planks were one foot wide and six inches thick. Stringers were laid every three feet, and the planks were attached to them with spikes. They extended from the curb to the streetcar lines. Though an obvious improvement over dirt and mud, they had their disadvantages. J.A.Q. Sproule, owner of the Cow Butter Store at Pacific Avenue and Jefferson Street, said their biggest disadvantage was that they were so flammable. Carelessly tossed cigarette and cigar butts, sparks from streetcar rails and firecrackers meant the smart shop owner kept a bucket of water handy to douse fires. Another problem was that spaces underneath the planks became handy hog wallows for wandering pigs, and according to rumors at the time, at least one escaped felon found a place under the planks in which to hide. Another problem was that Tacoma's elevation rose about 360 feet in just eight blocks downtown, and horses had a hard time getting traction on the slippery wooden inclines.

Different parts of town had plank roads for varying lengths of time. In 1892, the *Tacoma Daily Ledger* ran a scathing article on their state with physicians weighing in: there was no ventilation under the wood, which retained "dampness and decaying impurities." Added to this, they said, "the byproducts of horses," and you have a mess. City officials knew many of the roads, Pacific Avenue included, needed work, and the city attorney had to decide whether property owners could be assessed a second time.

Of course they could.

In 1895, workmen replaced Pacific Avenue's planks from Old City Hall to South Seventeenth Street with cedar blocks. The blocks were three to five inches thick and seven to nine inches wide. They were set on a foundation of six inches of gravel and concrete. Once in place, tar and asphalt filled in the crevices, and the surfaces were covered with sand. The city engineer

estimated that twenty-seven thousand square yards of wooden block paving could be installed at a cost of $1.40 per square yard. It was hoped that wood-block paving would spawn a big new industry. It did, but not until cars became popular and creosote was readily available. The St. Paul and Tacoma Lumber Company manufactured and marketed a line of creosote-treated fir blocks made specifically for streets. Their advertising brochure listed East Eleventh Street, including the approaches and deck of the Eleventh Street Bridge, Puyallup Avenue and North Twenty-sixth Street as places the blocks were used. Pacific Avenue's cedar blocks lasted about seven years before they had to be replaced.

As the twentieth century advanced, Tacoma wanted a more sophisticated appearance. The city engineer took a good look around and discovered people had been encroaching on the streets with barns, gardens, corrals, lumber piles, pastures and even cemeteries. The guilty parties were warned to move the obstacles, or the city would do it. Tacoma was sprucing itself up, but the blocks were wearing out. According to the Cambridge, Massachusetts Public Library in June 1902, Tacoma's Board of Public Works decided to give bituminous macadam a try.

On October 12, 1902, the *Tacoma Sunday Ledger* ran three feature articles heralding bituminous macadam. Three articles in one Sunday paper seems like a lot. Either it was a slow news day, or bituminous macadam was a revolutionary new product. Seattle was hosting a convention and meetings of the Good Roads Association, and delegates visited Tacoma to see it. The Warren Bituminous Macadam Company and the Barber Asphalt Company competed for the contracts to pave not only Tacoma's streets but many others in Washington State as well. Warren Bituminous won.

Men made bituminous macadam pavement by spreading two or more layers of material, such as crushed stone, on a suitable base and covering it with a bituminous binder, such as asphalt or coal tar. In Tacoma, men put down a foundation of various sized rocks usually two to two and a half inches in diameter and compacted them with a twenty-ton roller to a thickness of four inches, which provided adequate drainage for ground water. Over this went two inches of wearing mixture—mineral or stone that was dried and heated in a special dryer and then separated through screens into various sizes. Once sized, the stones were dumped into a "twin pug steam powered mixer" in predetermined amounts to "reduce the voids to about 10%," and then hot cement was added to fill any spaces and cover all the particles. The stones took the wear and tear, so the aim was for as little bituminous as possible. At the turn of the twentieth century, a mixture of sand and

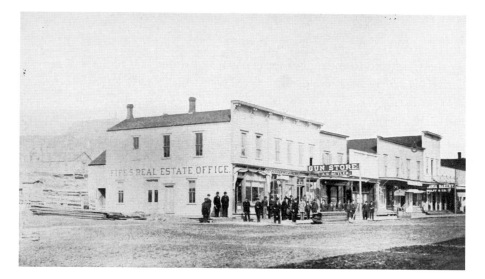

Looking north on Pacific Avenue from Ninth Street. *From* Tacoma, Its History and Its Builders: A Half Century of Activity *by Herbert Hunt. Chicago, IL: The S.J. Clarke Publishing Company, 1916. Archive.org.*

stone dust with asphalt as the cementing agent was the most common mixture. Referred to as sheet asphalt, many of Tacoma's neighborhood streets paved with this were not replaced for years. Some streets had various sized broken stones mixed in, while others were said to resemble tempered glass that had been hit with a hammer and shattered. However, perhaps the most interesting part of the procedure was this: dump trucks hadn't been invented. The mixture went into horse-drawn wagons, which were hauled to the paving site. The wagons had beds of loose boards. When the boards were turned on their edges, the hot mixture fell to the ground. Then men with scoops and rakes spread it around and used a heavy steamroller to compact it down. The final step was to apply a coating of fine stone chips that would stick to the bitumen and provide the rough, gritty surface. At one time there, was a medallion on the southwest corner of North Nineteenth and Alder indicating it was paved with Warren's Bitulithic Pavement.

Bituminous macadam was okay, but not good enough; the search for a better paving material continued.

What about bricks? They had a clean, attractive look.

In 1904, the *Tacoma Daily News* ran a full-page spread with before and after pictures of brick-paved roads. Residents long thought they came from ships' ballasts. According to F.A. McFail, an employee for the Public

Works Department, that was incorrect. The majority of Tacoma's roads bricks came from Seattle's Denny Clay Company, and a few that had been vitrified—glazed to make them impervious to water and highly resistant to corrosion and giving them the look of glass—came from Belgium. They were of uniform size and quality and were used on a section of Pacific Avenue; they were also very expensive. The PWD used them mainly for gutters.

Houston Fabricated Street Gutters were also being installed. They came from the Houston Treated Wood Company, owned by a Tacoma man named Ross Houston who had patents on the gutters in the United States and Canada. The gutters were carved from whole pieces of timber, treated for waterproofing and longevity and then set into place with stakes. Tacoma believed that the Northwest had an unlimited supply of timber—easily enough to edge the miles of roads that crisscrossed the city.

Between 1900 and 1905, almost six thousand buildings were erected in Tacoma. In 1905 alone, $1 million was invested in city streets; this time cobblestones were the medium of choice.

Many hilly streets were paved with cobblestones because they provided good traction for horses' hooves; sandstone cobblestones were preferred for the same reason. Tacoma's cobblestones came from Stuart Island in the San Juans, Stevenson along the Columbia River, Wilkeson and Index. Though Index was a gold mining area, in 1904, a man named John Soderberg started the Western Granite Works at a spot along the Skokomish River and cut granite from a solid thousand-foot wall. Rock climbers called it "The Wall."

Laying cobblestones was skilled work, not something done by cheap Chinese labor. A cobblestone paver made from $2.00 to $2.50 a day, but the more skilled workers made $6.00 a day for eight hours' work. The skill came in figuring out the foundation for each stone because they weren't uniform in size, and the end result was supposed to be a smooth surface. The process involved drilling and loading granite formations with dynamite and blasting it. Then quarrymen worked under tarpaulin tents, chipping and shaping blocks. Local cobblestones were loaded onto railcars and delivered to Tacoma. Those from Stuart Island were quarried the same way but brought here by ship. They were darker and often contained fossilized shells. That may be the source of the belief that Tacoma's cobblestones came as ship ballast. Some contractors sent railroad tickets to cities such as Quebec, New Orleans, San Francisco, Boston, Charleston and Baltimore offering to pay the transportation for men to come out here and work, at least temporarily. Unfortunately, the granite cobblestones didn't wear well, and the police department complained. On October 14, 1908, the department had taken

delivery of its first motorized paddy wagon. The maroon vehicle was underpowered and required a running start to make it up Tacoma's steep downtown streets. Added to that, the cobblestones punctured the wagon's skinny tires.

The Barber Asphalt Company had a good reputation and offices in every major city in the country. In Tacoma, the company employed about three hundred men, and its average monthly payroll was over $15,000. Why not give the asphalt a try?

And so it went.

Tacoma's streets began as rutted dirt, which was covered with wooden planks followed by wooden blocks and then sheet asphalt, macadam and bricks, followed by cobblestones and, finally, modern hot-mix asphalt.

To paraphrase Sonny and Cher: "And the search goes on."

THE FIRST AROMA OF TACOMA: A MUCH-NEEDED SEWER SYSTEM

Complaints are frequent and loud against the foul ditch misnamed a sewer, along the east side of Pacific avenue, and especially that part of it near the crossing in front of Gross Bros.' store. The stench from it is exceedingly offensive and has become a public nuisance.
–Weekly Ledger, *New Tacoma, Washington Territory, July 21, 1882*

And after the *Ledger* printed the above, Dr. James Vercoe weighed in. He wanted a general cleanup authorized and paid for by the city. This included removing rubbish from the streets, cleaning under the sidewalks and penalizing property owners who didn't keep their premises clean. "Let us not sit with folded arms like Micawbers," he said. (A Micawber was a poor person who waited for something to happen.) Two months and one day later, the Committee on Streets and Public Property, the Tacoma City Council and an unidentified man issued two contracts: one to Samuel Henry for construction of a sewer and the other to Richard Walsh for supplying the gravel and fill.

The sewer was to begin at a point on Cliff Street where it intercepted the center line of Pacific Avenue, run down the middle of Pacific to the middle of Fifteenth and Pacific and "thence over ground to be selected, and upon a line to be designated to running water at the head of Commencement

"Evaluating the Situation," postcard circa 1915. *Tacoma Public Library Photography Archive.*

Bay." In order words, the sewer line left Pacific at Fifteenth and ran down to the water, dropping no less than one foot per hundred feet. At the high tide mark, it was to be covered with not less than two feet of earth, and the low tide line was to be constructed so it was "well and sufficiently built to hold it securely in place."

Good weather favored the work.

Size and materials were as follows: each section would be eighteen inches wide and thirty-six inches high and built from cedar. The caps and sills were four by four inches and the studding four by six inches. The bents could not exceed five feet apart. Planks for the bottom were two inches thick and planed on one side and both edges. The sewer was to be lined on the sides with one- by twelve-inch boards dressed on one side and on both edges and planked on the outside with two-inch planks. The space between the lining and the outside was to be filled with "good clean soil." The top of the system was to be covered with two-inch planks laid crosswise. Fancy words for a rectangle within a rectangle.

At the middle of Pacific and at each cross street, manholes with construction similar in materials and size were parts of the contract. Cast-iron gratings helped with the surface water. The contracts also had many other requirements, such as the use of ten-penny nails, but the most important was the completion date: on or before November 24, 1882. Just

before completion, a Puyallup man named Thomas Twombley started across Pacific near the Halstead House Hotel, lost his footing and fell fifteen feet into the sewer ditch. The men who hauled him out took him to the hotel and called for a doctor. Mr. Twombley had a broken thigh and other injuries.

The sewer was declared done on November 24, but the road was still piled with dirt from the trenches. In December, a wagon driver was forced to unload part of his dray when it became stuck in the ruts; an additional team of horses brought in to assist the existing team was unable to extricate the wagon. Not long after, another horse, driven too close to the sewer ditch, slipped in what had become soft, slimy mud and went in up to his neck. Large crowds gathered to watch a team of horses pull it out.

In the meantime, nine cars of gravel were making seven to nine trips daily, on a makeshift track, to where sixty Chinese men and a few white laborers were working as fast as they could to fill in the trenches and smooth the surfaces.

Complaints began as soon as March 1883 when the *Ledger* reported grumbling among citizens about the sewer's inadequacy. Apparently, saloon owners and some employees on Pacific Avenue's west side were throwing their dirty water out their back doors. One report said, "It runs under buildings and becomes foul cesspools breeding all manner of diseases." Investigations revealed that in some instances no sewer connections had been provided.

Members of the Tacoma Street Department, postcard, 1915. *Tacoma Public Library Photography Archive.*

The following month, unemployed men found work digging trenches from businesses to the main sewer line so connections could be made. A week later, anyone going to town quickly became aware that the sewers were in danger of collapsing and becoming useless. The problem was cave-ins in the middle of the road. In September, repairs began. In October, people near Pacific awoke at midnight to a deep, funeral sound of someone calling for help. Searchers found a man in one of the sewer's open holes. They pulled him out unhurt, but not long after, the main between Thirteenth and Fourteenth Streets collapsed.

Men kept making repairs, and gradually the complaints stopped—until it came to light that the sewer had been built without a bottom.

Soda Works

Called on A. Harrison and found he was at Carlisle, but that we were expected to supper; excused ourselves on the necessity of eating at the inn; supped there upon trout and roast foul [sic], drank some most admirable cyder [sic], and a new manufactory of a nectar, between soda-water and ginger-beer, and called pop, because "pop goes the cork" when it is drawn, and pop you would go off too, if you drank too much of it.
—Robert Southley, 1812

One thing that was true of every frontier town was that they were populated by thirsty, hardworking men who wanted beer. And saloons were among the first buildings to go up. Until the advent of local breweries, beer was shipped in from larger cities, but as soon as a brewmaster arrived, he usually started to make his own. In 1880s New Tacoma, however, and for a while, at least, newspaper coverage about breweries took a back seat to the new Soda Works Company.

In 1882, a man named Charles Riley announced that he and his son planned to build a factory between Eleventh and Thirteenth on the west side of C Street (Broadway) and make root beer, cider and soda water. Soda water, which is merely water into which carbon dioxide gas under pressure has been dissolved to give it its effervescence, is, of course, the major ingredient in soft drinks. And for those who remember downtown Tacoma before the mall, that would put the company about where Sears used to be.

Three months passed before the equipment Riley ordered from the East Coast arrived. In November, he told a *Weekly Ledger* reporter he was prepared to manufacture not only soda water, cider and root beer, but also ginger ale and champagne and that he had a line of customers in Puyallup, Carbonado, Olympia and other nearby towns as well as in New Tacoma. He was already considering enlarging his premises.

A brief background shows carbonated water dates to 1767, when a man named Joseph Priestley first discovered a method of infusing water with carbon dioxide. He did so when he suspended a bowl of water above a beer vat at a local brewery in Leeds, England. He was followed, in the late eighteenth century, by J.J. Schweppe, who developed a process to manufacture carbonated mineral water based on Priestley's

Left: Popular beverages, compiled from old ads. *Author's collection.*

Below: Tufts' Arctic Soda advertising postcard, 1870–1900. *Digital Commonwealth, http://ark.digitalcommonwealth.org/ark:/50959/3b591d537.*

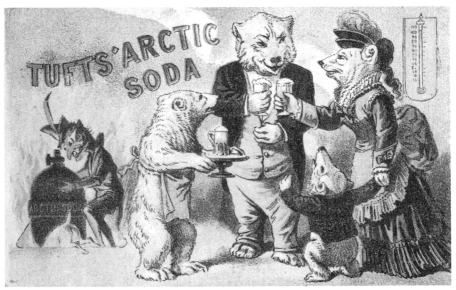

process. In 1783, Schweppe founded the Schweppes Company in Geneva. It fell to Hungarian Ányos Jedlik, however, to invent the consumable soda water that we drink today. Jedlik built his own carbonated water factory in Budapest, Hungary. During the Great Depression, carbonated soda water was sometimes called "two cents plain," a reference to its being the cheapest drink at soda fountains. In the 1950s, terms such as sparkling water and seltzer water gained favor.

During colonial times, apple cider was the main beverage served with meals because water was often unsafe for drinking. Ciderkin, a slightly alcoholic beverage made from cider pomace, could also be found on colonial tables. Sometime after Prohibition, the word cider "came to mean unfiltered, unfermented apple juice." We now use the word for both fresh-pressed juice and fermented products, although the latter are often called hard cider. Apple juice, meanwhile, refers to a clear, filtered, pasteurized apple product.

Pharmacist Charles Hires introduced the commercial version of root beer at the 1876 Philadelphia Centennial Exhibition. However, it was seventeen years before root beer was sold to the public as a bottled soft drink. During Prohibition, nonalcoholic versions were commercially successful. By 1960, however, the U.S. Food and Drug Administration banned a key ingredient (the sassafras root), calling it a carcinogen. Following this ban, companies started experimenting with artificial flavors and preparation techniques to remove the unhealthy effects of root beer while preserving its taste. Meanwhile, back in New Tacoma, Mr. Riley sold the Soda Works Company four months after the machinery's arrival to men identified only as Messrs. Marr and Taylor.

Badly Hurt by Exploding Bottle

William Ayers, mate of the steamship, *Dove*. Went to the ice box on the steamer yesterday afternoon to regale himself with a bottle of cold soda pop. Instead of pressing the wire against the side of the ice box to open the bottle, the mate hit the cork a smart rap with the palm of his hand, which is generally sufficient to open such a bottle. Simultaneously with the blow the bottle exploded. One large piece of glass sheared off two of fingers as clean as if they had been cut off with a surgeon's knife.

—Tacoma Daily News, May 23, 1908

According to the paper, both were experienced manufacturers. The tree sassafras they used was indigenous to eastern North America; southernmost Ontario, Canada; through the eastern United States; south to central Florida; and west to southern Iowa and East Texas, saving money on importing fees.

The first thing the pair did was order a David M. Ford and Company soda machine from Chicago. The machine had three horizontal cylinders. The first held the gas, and the second and third refined the beverages. The soda machine's capacity was 200 bottles a day. It was capable of making ginger ale and champagne at the same time, plus a new drink—sparkling nectar. Within a matter of weeks, the two men's monthly output was 200 dozen bottles of soda, 100 dozen of champagne cider, 100 bottles of ginger ale and 50 bottles of sparkling nectar. Messrs. Marr and Taylor felt good about their company's prospects, and their instincts were correct. After the first month, the company's output grew to 15 dozen bottles of sparkling nectar, 160 dozen bottles of ginger ale, 100 dozen bottles of champagne cider and 296 dozen bottles of sarsaparilla. They enlarged their factory by rolling the building farther back on the property.

Six months later, the company advertised with a giant painting of the Puyallup Reservation in the foreground and Mount Tacoma behind. The new owners said, "The snow-clad mountain is very suggestive of a cooling drink of soda water."

Good instincts or not, sometime over the next six years, Tacoma Soda Works seems to have disappeared. Tacoma's 1888 *Polk's Directory*, the oldest in the library, doesn't have it listed.

FIRST CENTRAL SCHOOL

Superintendent Gault of the city schools has not been pleased that the races of the firemen's tournament have been held on Yakima Avenue just in front of the Central school building. School in the Central school building was dismissed early on Tuesday, and the pupils have been enjoying a vacation ever since. The other schools have also been dismissed since Tuesday. "We could not keep school in the Central building," said Superintendent Gault yesterday, "while the races were in progress so we closed up school altogether."
–Tacoma Daily News, *September 20, 1889*

Pierce County had a town briefly in 1855. It was near a place in Lakewood where two men had been massacred by Indians. Then, county development

more or less disappeared until the 1860s, when Job Carr landed on what would become Old Tacoma. By the 1880s, there were three small schools: North School House, an Episcopal school on St. Helen's Avenue and a third near Twenty-First Street. Their total seating capacity was two hundred. When the first Central School opened, the student body totaled 425 and encompassed first through eighth grades.

In the summer of 1882, New Tacoma residents passed a $5,000 school construction levy. The final cost would be closer to $25,000, but the levy was a start. The site chosen was an undeveloped lot 280 feet by 300 feet at Eleventh and G Streets, where Bates Technical College is now. Not all taxpayers were thrilled with the location. The land was surrounded by brush and stumps, and some people considered it too far out of town. Tacoma would never grow that far west, they thought. As is generally the case, public opinions were overridden.

The new building was 80 feet wide and 119 feet deep, with a basement where children played in bad weather, and twelve classrooms on two floors. Doors on the first floor opened into a 116- by 14-foot hallway off of which a stairway led to the second floor. One hundred and eighty windows provided the building's only light. Two furnaces and boilers provided heat and hot water. The girls' entrance was on G Street and the

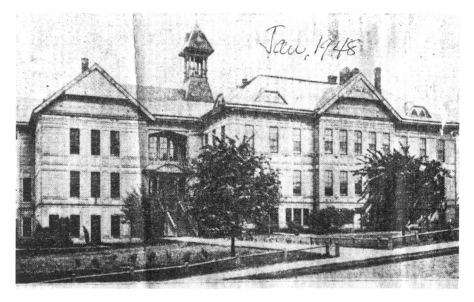

The First Central School, circa 1888, *Tacoma Daily News*.

boys' on Yakima Avenue. At the grand opening, a lot of people objected to that arrangement. Plans called for an assembly room on a third floor, but that was halted for lack of funding.

The first Central School was intended to be a showcase of Tacoma's skyline. The peaked roof was sixty-eight feet high, and a bell tower rose above the front entrance. The tower had a three-hundred-pound bell cast in Tacoma.

An elaborate dedication ceremony on November 12 brought out most of Tacoma. Prominent businessmen spoke, and some of their comments are surprisingly contemporary.

"In England," one man said, "there was [only] one school for every 700 eligible boys and girls, and 90 percent of the country's criminals were either partially or entirely illiterate. In New England 80 to 90 percent of the criminals were unskilled, and 75 percent of the crimes were committed by the illiterate and unskilled."

Over the next four years, Tacoma experienced phenomenal growth. By 1886, student enrollment and the number of teachers at Central more than doubled. Three annexes had been added, but then, as now, school board members hated portables. Other schools were going up in other parts of town. School funding was depleted within two years. As a result, classes ended a month earlier than they normally would have. The school board decided Central was inadequate. Nevertheless, it wasn't until 1913 that a new Central School was built, this time at South Eighth and Tacoma Avenue. One of its innovative features was a domestic sciences facility, where girls were taught how to properly make a bed (there was one in the classroom), how to use modern laundry facilities and how to dress appropriately. Another feature was a set of special rooms with south-facing windows that could be kept open for children with tuberculosis.

After the new school opened, the old school was converted into a homeless men's shelter. In January 1914, a man named Jeff Davis went to the mayor's office to talk about the needs of Local 23 Hoboes of America. Jeff Davis had popped onto the scene at a Good Roads convention in Detroit. He was advocating road construction jobs both to help unemployed, homeless men find work and get back on their feet and to make getting around easier.

Central School number one was scheduled for demolition, but Davis arranged with the contractor to leave the G Street end of the building intact for as long as possible so the men could sleep there until the weather warmed up. Old Central then became known as the Hotel de Gink. Gink was slang for an eccentric person, ergo the Hotel of Eccentrics. City and county

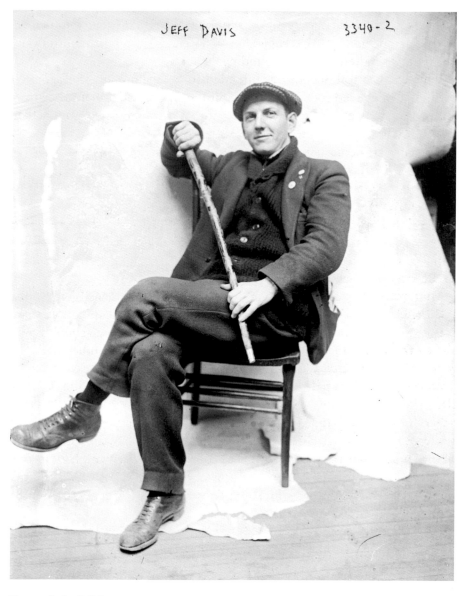

JEFF DAVIS 3340-2

Famous hobo Jeff Davis in his prime. *Library of Congress, Prints & Photographs Division [LC-DIG-ggbain-18102].*

commissioners provided blankets. Davis borrowed an old stove and begged people for firewood. He also got milled wood that the men used to make chairs and benches. The hoboes then decided to put on a minstrel show. They charged twenty-five cents admission, and the money earned went to

Annoyed by school boys running across her lawn and playing mischievous pranks, Mrs. Davidson, residing at the north east corner of Ninth and G Streets stretched a low wire fence along the front of the premises and coated the stakes and wire with tar. Yesterday the boys continued the spirit of mischievous fun depriving themselves of a portion of their noon luncheon and placed a donut on each stake of the fence. Mrs. Davidson appears to have been watching. Taking the bucket of tar and stealing up the street, and stealing unawares on one of the boys, proceeded to empty the bucket down his back.

—*Tacoma Daily News*, March 1, 1905

make mulligan stew. The newspaper's only comment was that the show was definitely "one of a kind."

Throughout the winter, when the wind blew and rain poured down, the men ate stew, wrapped themselves in their blankets, smoked corncob pipes, told stories and played cards. The paper said there were no disturbances, and the neighbors had never had a need to complain.

Jeff Davis moved on to other towns, leaving a man named Walter Tyrell in charge. Tyrell and the men asked the mayor for help, and there was an attempt to establish a community farm just outside of Tacoma where they could raise their own food. The plan fell through, but by that time spring was approaching. Lumber camps and railroads needed men, and other employment opportunities also popped up. The men got jobs, and the school-cum-hotel was demolished in 1914 but not before the bell was moved to the new school.

Once the old school was down, people lobbied to turn the land into a campground for automobile tourists. Nothing came of that idea; the property was considered the right place for a big new auditorium. Nothing came of that idea, either, but on July 26, 1927, a playground with tennis courts was dedicated there. The playground lasted until 1941, when the school board decided the property was better suited to a vocational school.

ALPHA OPERA HOUSE

Two handsome and evidently expensive theater lamps raised high upon posts and stationed at the outer edge of the sidewalk on either side of the main entrance to the Alpha Opera House add effect of appropriate finish to the front exterior of that creditable institution, and when lighted at night illuminate the street and houses for a good part of the block.
–Weekly Ledger, *July 21, 1882*

The year 1882 was when New Tacoma started getting amenities: new hotels, a sewer system and the Alpha Opera House.

The opera house was on Pacific Avenue's east side between Tenth and Eleventh Streets. The facility, built by bankers Baker and Sprague and run by their sons, was 44 by 110 feet, 20 feet high and sat seven hundred. If business was good enough, two hundred more seats could be added. The chairs were special order from Portland, arranged to provide a 6-foot-wide center aisle and 3-foot-wide aisles on each side. A Brussels carpet covered the stage. Under the stage were ladies' and gentlemen's dressing rooms with hot and warm running water and a furnace. A 14-by 44-foot gallery extended across the hall on the western side. There were seventy-two lights, but most prominent were eight chandeliers, each hanging from large rosettes on the ceiling. The footlights were arranged so they could all be quickly lowered by one man. The idea was to emulate gas lighting, which apparently could also be quickly handled in the same way. A Seattle man named A.W. Piper was responsible for the scenery, each of which was 14 by 22 feet. The stage drop cloth was painted, but the paper doesn't say what it looked like. It did say that the stage was inclined toward the front in order to provide good viewing from all parts of the auditorium.

Even in the 1880s, people were aware of ventilation problems in large public halls. The opera house had a Cottier Ventilation system "by means of which vitiated [reduced] and impure air is rapidly and without subjecting the audience or persons on stage to unhealthy currents, taken up and forced out through the roof. And a plentiful supply of pure air furnished." W.T. Cottier filed for a patent on his ventilator in 1889. He also patented fruit crates and wardrobe closets.

Back then, fire was always on everyone's minds. In addition to the opera house's front and rear doors, which swung out, there were five large windows that opened into the alley. The windows were hung with weights and pulleys

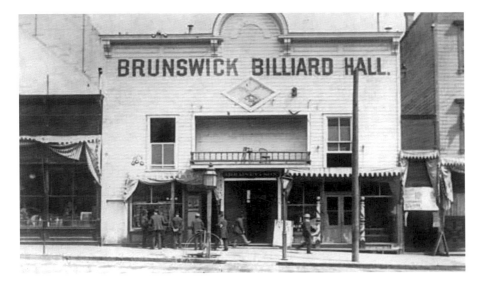

Alpha Opera House after it was converted to a billiard hall, only known photograph. *Tacoma Public Library Photography Archive.*

so that with one quick motion the lower part opened, allowing people to step over the sill and out. Estimates said in case of emergency, the theater could be emptied in three minutes. And finally, opera lamps stood on each side of the front door.

The opera house opened for business on May 30, 1882, with entertainment provided by the Standard Minstrels, a 22-member company that had been held over in San Francisco for eight months. The *Portland Oregonian* raved about them. The act was part blackface and part Irish music and skits. On opening night, the opera house was sold out. The next night, there were only 150 people. The *Weekly Ledger* had a few snide remarks about the *Oregonian's* theater critic.

Reading about performances at the opera house is a good reminder of how fleeting fame is because many of the entertainers, though now forgotten, were very well known in their time.

Take, for example, Julie Rive-King and her company. Madame Rive-King, as she was called, was only twenty-five and already an internationally known pianist when she played in Tacoma. She studied with Lizst, and her repertoire included Bach, Handel, Schumann, Chopin, Moszkowski, Liszt and some later composers. Her company included a man named W.H. Kinross, who may have been a professor of voice culture and vocal music in Oregon; Mrs. A.E. Stetson, who may have been the lady of the same name

who was a good friend of Mary Baker Eddy; and Miss Annie Griffin, who isn't anywhere on Google. They played to full houses.

After acting in other people's troupes, actress Nellie Boyd rose to stardom, heading a company of her own. Hers was one of the leading traveling troupes to entertain audiences for more than a decade. In Tacoma, she stared in the play *Franchon the Cricket* at matinees and *East Lynne* in the evenings.

In the 1870s, white entrepreneurs bought up and ran most of the successful black companies. Charles Callender obtained Sam Hague's troupe in 1872 and renamed it Callender's Georgia Minstrels. They became the most popular black troupe in America. Despite the revenues brought in by his star performers, Callender ignored their demands for more pay and better recognition. Some of them quit and formed their own company, an action Callender claimed was tantamount to theft. The issue came to public attention for its racial implications, and most of the performers who had left eventually returned to Callender. The company stayed at the top of black minstrelsy through the mid-1870s. In 1874 or 1875, Callender organized a second troupe of black minstrels that toured secondary circuits, such as the Midwest. After a bad year in 1877, he sold his main troupe to J.H. Haverly but continued to operate his secondary troupe, which is probably the troupe that played here.

In her day, Hattie Moore was very well known; so was *Olivette*, the comic opera in which she appeared in Tacoma. Bessie Louise King came to Tacoma with the Boston Comic Opera Troupe. Miss King had an opera-quality voice, but in 1871, Gilbert and Sullivan started writing comic operas, which became very popular. She was so well known that the *Ledger* called her appearance here "An Event in Tacoma History."

Other entertainers to perform at the opera house included Madame Modjeska, an internationally renowned Shakespearean actress; stage star Anne Pixley; vaudeville star Katie Putnam; opera singer Emma Abbott; and Shakespearean actor Frederick Warde. Warde was an interesting fellow. His acting partner was Maurice Barrymore. They agreed to tour the United States but divided the towns between them. Writer-humorist Bill Nye wasn't as famous as Mark Twain, and his appearance at the opera house wasn't well received. When only sixteen people and a yellow dog showed up, he left without performing. John L. Sullivan fought in the opera house. And the only public address Tacoma's benefactor Charles Wright gave here was there.

If the opera house wasn't hosting entertainers, various local organizations used the facility. When two local preachers and a San Francisco businessman spoke, fifty people signed the pledge (not to drink).

Bad weather kept the expected speakers away from a Republican rally in November 1882.

Also in November, a group of Seattle people chartered the steamer *Zepher* and came down to put on a concert; it wasn't successful. The singers were late, the theater was cold and not ready for them and practically no one showed up due to lack of advertising.

Members of a Tacoma bicycle club fared much better when they put on a performance involving blocks and teeter boards and using not only bikes but also unicycles and wagon wheels. The evening concluded with a dance and lantern parade.

The Presbyterians held a number of fundraisers, such as strawberry festivals and ice cream socials, at the opera house; anti-Chinese meetings and statehood celebrations also took place there. And on occasion, when the weather warmed up and ice skating ended, the room was cleared out and made available to roller skaters. Management sent to San Francisco for four dozen "improved" skates and eighteen pairs of double-wheeled skates for men who wanted something finer. It anticipated keeping one hundred pairs on hand to rent.

The Alpha Opera House's heyday ended when the magnificent Tacoma Theater opened in 1890 on C Street (Broadway), and the opera house became a billiards parlor. The building was torn down in 1892 and replaced by Chilberg's restaurant. In 1928, the Bank of California building was constructed on the site.

When Stomachs Rose and Fell with the Tide: Oysters

Gasoline got in its deadly work last evening, totally destroying a small tent restaurant at the corner of C and Eleventh Streets owned by William Mayer, better known as "Oyster Billie." The cook was filling his gasoline stove. There was one customer in the dining room. All at once, the stove exploded in a rude and boisterous manner…scattering the blazing oil which enveloped the place. The cook was blown out the back. The waiter and customer made a simultaneous rush for the street. Oyster Billie grabbed a round glass case with a Derby race inside that starts by dropping a nickel in the slot and carried it to safety. The horses [in the slot machine] were not injured.
—Tacoma Daily Ledger, *September 11, 1930*

Boston's Union Oyster House, which opened in 1826, is the United States' oldest oyster bar, but oyster palaces in San Francisco weren't far behind. When, for various reasons, people headed for California, they brought their tastes for seafood with them. Pacific Northwest lumber soon helped build the town, and freshly caught Puget Sound Dungeness crabs, clams, oysters and mussels were cooked up to feed San Francisco's residents. At the height of oysters' popularity, there were oyster houses, parlors, cellars, saloons, bars, lunchrooms and stalls in cities all over the country, and Tacoma was no exception. Between 1890 and 1948, on Pacific Avenue alone, oysters were the specialty at the Fifteen-Eighteen Cabaret, the American Oyster House, the California Oyster House, Peter's Golden Gate Oyster House, the Young Oyster House, Lee's Oyster House Restaurant and the Fisher's Oyster and Chop House. And up on Durango Street, workers at the American Biscuit & Cracker Company were baking oyster crackers.

Virginia native J.W. Russell was one of the Pacific Northwest's first settlers to market shellfish. In 1851, he hired natives from the Chinook and Chehalis tribes to harvest some of the Willapa Bay oysters, load them onto small flat-bottomed boats called *bateaux* and take them to the Columbia River. From there, Mr. Russell shipped them to San Francisco.

Around 1900, a New Orleans street cart oyster vendor hung up a sign reading, "Improve Your Sex Life. Eat Oysters." Suddenly, supply couldn't keep up with demand. They were corned; curried; pickled; served raw; made into stew; stuffed in the Christmas turkey; turned into soup; wrapped in a roll, cabbage or bacon; baked; grilled; served on buttered toast points, known as Angels on Horseback; or wrapped in thin slices of beef or ham to make oyster purses. Since so many people were eating them, a special oyster plate from which to serve them was created. The first plate, made in the 1870s, was designed to hold crushed ice or clean, packed snow on which the oysters in their shells could rest. The plate, however, turned messy as the snow melted. It was redesigned with depressions in which the shells could rest. The

> **Now Oysters May Go Up**
> A shudder ran through the community today when rumor spread a report around town that oysters had gone up. So many of the old daddy oysters have been eaten up by ravenous cocktail devotees that the whole tribe is running out.
>
> —*Tacoma Times*, February 9, 1910

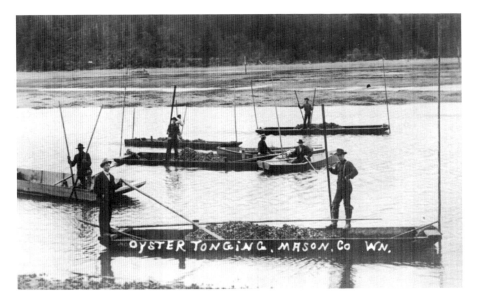

Going after oysters in Mason County, photograph postcard 1910. *Tacoma Public Library Photography Archive.*

drawback to this plate was that the shells scratched the china. A final design had shell-shaped depressions that kept them from wiggling.

Meanwhile, in Olympia, a fifty-five-year-old Maine sea captain named Woodbury J. Doane saw the seemingly unlimited acres of oysters free for the taking on the tide flats. Keeping in mind their popularity, he decided to retire from the sea and open a little restaurant off Main Street (now Capitol Way). Initially, Captain Doane raked the oysters in the morning and cooked and served them in the afternoon and evening. As the restaurant caught on and expanded, he hired a Chinese cook who, on an average day, cooked sixty gallons. Doane's restaurant became a popular meeting place for politicians, statesmen and travelers, thanks, in part, to the house special, an oyster pan roast. To make a pan roast, the cook sautéed one generous cup of oysters in four tablespoons of melted butter and then added a cup of tomato catsup, one tablespoon of Worcestershire sauce, one scant teaspoon of Tabasco and salt and pepper. The mixture was served on toast.

By the turn of the twentieth century, native oysters were commercially extinct. An East Coast practice of setting "spat" (shellfish in their tiniest form) was introduced to revive the industry. The spat came cross-country by rail and was transplanted in areas such as Willapa Bay. This practice

continued until the 1920s, when Japan began exporting spat. It continued until the 1970s, when local hatchery production took over.

Back in Tacoma, however, the popularity of oyster houses had declined, and other businesses were replacing them. Only one restaurant, the California Oyster House, was still doing well, but seating was limited and parking on Pacific Avenue was a problem. Forty years after it opened, owner John Barcott Sr. relocated the restaurant to a spot three blocks north of the Old Tacoma Dock and called it Harbor Lights. It is Tacoma's sole survivor of the oyster heyday.

RECREATION

A Grand Calico Ball will be given by the Tacoma Spiritualist Society at Columbia Hall. Those who are not able to afford a calico dress may come in their silks and other gowns. The ticket price is 50 cents, and ladies are admitted free.
—News Tribune, *November 12, 1909*

In September 1883, several New Tacoma businessmen began laying out a racetrack on land four miles south of the Oakwood Cemetery at an area known as the head of the prairie. A wide belt of young, low-growing evergreens with a fir-covered ridge behind bordered an open space approximately half a mile long and a quarter of a mile wide. For years, sheep, cattle and horses grazed on the land. They left behind a gravelly plain with a thin layer of topsoil. The spot seemed "by nature" to have been placed there for a racetrack. Besides which, the locals were frowning on racing on Pacific Avenue.

A settler, Thomas Kenevan, had a homestead due south of the chosen site. Mr. Kenevan sold ten acres of land, and the Tacoma Land Company made up the balance of acreage needed. The area was surveyed and staked off. Grading began for an initial twenty-foot-wide course to be increased to sixty feet wide in spring 1884. Plans called for enclosing the facility with a nine-foot-high board fence, sheds, stables and a grandstand and pavilion for spectators. The course opened in 1885 under the name Tacoma Driving Park—and lasted about three years.

Also in 1883, the Scotsmen in New Tacoma organized the Caledonian Club for those with Scottish ancestry. Initial membership included a Campbell, Fraser, Gordon, Macleod and McKay. Their president—or the

Unusual Tacoma Organizations
 Holding Picnics
The German Druids
Fern Auxiliary
Women's Study Club
Modern Woodmen
Eureka Degree of Honor #2;
Brotherhood of the American
 Yoemen
Detroit Social Club
Tacoma Caledonians
The Hoosiers
Labor Forward Movement

CLUBS
Undine Rowing Club
Whistling Club
Esperanto Club
Owl Club
Mazama Club
Aloha Club
Rudder Club
Opti-Mrs. Club
Amateur Dramatic Club
Women's Amateur Musical
 Club
Bachelor's Club

Women No Longer Have Time for Sewing and Mending: The
 Unused Work Basket
Are too Many Study clubs.

—*Tacoma Daily News*, April 12, 1895

Great Chieftain, as he was called—was A.C. Campbell, who was also a Worthy Master for the local Odd Fellows.

East of the Rhine and north of the Danube was a section of Europe known as Germania. And Tacoma residents with roots in Germania organized Germania Societies. Members liked to put on masquerade balls. In October 1883, they celebrated Germantown, Pennsylvania's 200th anniversary with a banquet, speeches, songs, toasts and dancing. Approximately 150 people attended.

However, dances in New Tacoma weren't always costume balls or even fancy dress. Calico balls were popular, too. Both calico and muslin are plain-woven cotton fabric, but the name also applies to inexpensive, lightweight and generally a colored cotton fabric, named for Calicut, India, from which the fabric originated. Women who couldn't afford more expensive material used calico for gowns, bodices, petticoats, jackets and bonnets that they wore to country "frolics,"—lighthearted neighborhood gatherings.

In the pre-electronics age, organizations abounded and were well supported. In Tacoma, Professor Corrigan's dancing school created a minstrel group. The Tacoma Club organized. The YMCA was active, and residents started an amateur theatrics company. People created literary

An old ad for horseback riding, circa 1895. *From* Tacoma Times.

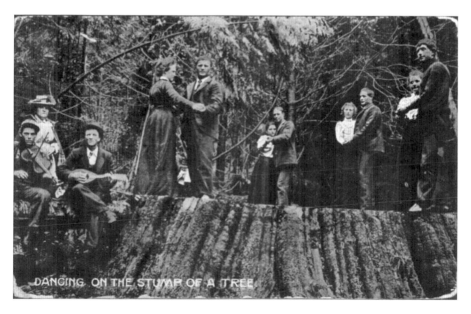

A cedar stump thirty-nine feet in circumference made a good dancing platform, postcard circa 1909. *Tacoma Public Library Photography Archive.*

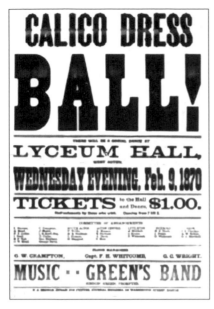

Advertisement for a calico ball. *Author's collection.*

societies and discussed literature or listened to lectures or debates or debated themselves on issues such as women's suffrage or whether convict labor should be abolished. A good literary meeting had recitations, duets, readings and plenty of musical solos. Mountain climber Fay Fuller spoke at one, and a man named W.J. Dean lectured on Benjamin Franklin's theory of electricity at another. Franklin felt that electrical fluid was responsible for a lot of electrical phenomena. In his Leyden Theory, Franklin said a Leyden jar, or Leiden jar, "is a device that 'stores' static electricity between two electrodes on the inside and outside of a glass jar. A Leyden jar typically consists of a glass jar with metal foil cemented to the inside and the outside surfaces, and with a metal terminal projecting vertically through the jar lid to make contact with the inner foil."

When a holiday came around, the whole town participated. In spite of living on the water, swimming wasn't a popular recreational activity, but holidays such as Fourth of July had plenty of athletic events. They usually included Indian canoe races, double scull and yacht races, a sack race, a wheelbarrow race, a standing long jump contest, a running long jump, a running high jump, high leaping with a pole, a sledge hammer throw, tug of war and shorter races for boys. The women were presumably cooking. Pacific Avenue was decorated with tree boughs and flags, many of which had been carried on battlefields. Trains brought people from Puyallup, Carbonado, Alderton and South Prairie, and Indians came by canoe, wagon or horseback. They particularly excelled in the footraces. Local bands played, and dignitaries such as the mayor, members of the Grand Army of the Republic and the Knights of Pythias paraded. There were public speeches, scripture readings and the reading aloud of the Declaration of Independence.

However, those lucky enough to be invited to the private party that Mr. and Mrs. Samuel Wilkeson hosted played cards, played or listened to music, danced, strolled through the lighted garden and enjoyed a midnight dinner. In July 1883, approximately seventy people attended the Wilkesons' party.

Picnickers, circa 1900. *From* Tacoma Daily News.

Next Week's Attraction at the Crystal Theater

Robert Nome—in a musical and whistling act. He is the only man on earth who can whistle entreatingly through his nasal organ.

—Tacoma Daily News, July 23, 1904

In mid-December, Christmas trees started appearing on the streets, but a tree was often something on which people tied gifts for friends or teachers. Nearly every religious demonization had a tree of this kind. On Christmas Day, people called on their friends.

Tacoma used to be a much colder place. In January 1883, Frank Alling, who lived near Wapato Lake, reported that all the nearby lakes (a number of lakes dotted an area of approximately 1.25 square miles near Wapato) had frozen over with ice some three inches thick. Large numbers of skaters converged on the lakes during the day and held skating parties at night.

New Tacoma residents were also interested in Native American artifacts. Mr. Wickersham displayed his in Mr. Bonney's drugstore. Included were a stone hammer, skin-cleaning implements, a stone pestle from Vashon Island and a mortar used to mix war paint. Mr. and Mrs. Blackwell left their collection to the Washington State Historical Society. Mrs. Blackwell was active in exchanging shells with other collectors. She and her husband and niece Ruby regularly made trips to Day Island to find shells unfamiliar to East Coast collectors.

The *Tacoma Daily Ledger* covered every church social held, be it Episcopal, Methodist, Congregationalist or Presbyterian. One of the most unusual might have been the Mum Social. The doors opened at 7:30 p.m, and as people arrived they were shown a chalk line drawn on the floor. After crossing the line, no one was allowed to speak. Those who slipped up were fined ten cents. J.W. Fife put on a pantomime performance of one of Shakespeare's plays, and "the boys in blue" entertained guests with a silent drill. Not until refreshments appeared were people were allowed to talk without fear of fine. Fees collected for admission and when people forgot and talked totaled thirty-seven dollars. The newspaper accounts of the party don't say where the money went. Only the Catholics and Jews failed to have socials opened to the public.

Life back then, and more or less until television came along, revolved around family, friends, church and school—very nostalgic.

In the meantime, movies came to town.

Fun for Tacoma Young Ladies

Some of the young ladies of Tacoma are talking about getting up a rainbow party. It is the fashionable craze in many parts of the country. The young ladies assemble in the evening wearing some simple, pretty toilette, the striking feature of which will be a bright-hued apron of cambric or silesis, carrying with her a gentlemen's [*sic*] necktie of the same shade, every color of the rainbow being represented in the variety of aprons and ties. The latter will be shaken together in a hat and the gentlemen will draw for them. The tie matching the apron worn by the respective young lady will decide his fate as her escort to the dining room, and moreover assigns him to the agreeable task of hemming the hitherto unhemmed apron. A prize is awarded to the young man who makes the best hem and another to the young man who makes the greatest botch of the allotted task.

–*Daily Ledger*, November 7, 1886

THE FLICKERS

In 1878, a man named Eadweard Muybridge used multiple cameras and multiple photographs and made the first motion picture: *The Horse in Motion*. However, "the world's earliest surviving motion-picture film showing actual consecutive action is *Roundhay Garden Scene*." French inventor Louis Le Prince made the 2.11-second film in 1888. Just five years later, three men opened a theater in an old building at 917 Pacific Avenue, hung up some sheets and stood outside acting as barkers to attract an audience.

As J.F. Shaw later explained it, the venture started when his brother and a French photographer persuaded him to finance their venture in "the flickers." To pay for the enterprise, they bought a still camera that took twelve- by twelve-inch pictures and started walking through Tacoma's neighborhoods. When they found a "likely-looking house," they stood outside and fussed around with the equipment to entice the homeowner outside. When asked what they were doing, the men explained they were taking pictures of Tacoma's most beautiful homes for a magazine. And would he/she mind if they photographed their home? If the owner took the bait and asked if he could purchase a copy, the men put film in the camera. If not, they shot a blank.

When that palled, the men, using most of Shaw's savings, bought "a new-fangled moving picture machine" and opened the theater with two films: a bullfight and a dancing lady. Both Shaw and historian Murray Morgan say the woman was Fay Fuller, but it was probably Loie Fuller, a pioneer in modern dance. Fay Fuller was a Tacoma resident and the first woman to climb Mount Rainier. At any rate, Shaw's brother's job was to run the projector, and the brother could do only one thing at a time. One evening, when the film stuck in the machine, Brother Shaw forgot to turn off the flaming carbon lights. Blazing material fell and burned up the other reel. Two hook-and-ladder wagons charged down Pacific Avenue, one each from the A Street and St. Helens Avenue stations, and flooded the building with water, knocking the projector over. The fire chief told the men their "movie contraption was a hazard" and warned them not to open another movie house.

However, not all the firm was ruined, and the French photographer had another idea: outdoor movies. The men hung cloth on the Ninth Street side of the Donnelly Hotel and rented a room across the street from which

Donnelly Hotel advertising its Grand Theater, postcard circa 1910. *Tacoma Public Library Photography Archive.*

to project out a window. Some local merchants signed contracts for advertisements to be shown with announcements of their latest bargains.

The first night was such a success that the audience blocked Ninth Street. This time, the police went into action and

> The four Montana boys who held up a train and murdered one of the passengers were no doubt influenced by dime novels and train robbery films.
>
> —*Tacoma Daily News*, June 5, 1908

told the crowd to keep walking. The trio was told to "cease and desist," and the merchants' advertising money had to be returned. J.F. Shaw moved to Vashon Island, taking the projector with him, and opened a combination drugstore and museum. Brother Shaw and the Frenchman disappeared into history.

Tacoma's motion picture business then hibernated until 1898, when Sally Chandler (Mrs. M.M.) Sloan opened the Searchlight Moving Picture Theater, oddly enough, in the Donnelly Hotel. According to the *Tacoma Daily Ledger*, it was only the second theater in the whole country entirely devoted to showing motion pictures.

Tacoma's first official movie house had rows of seats on a level floor and twenty-five feet of canvas suspended from the high ceiling and on which the pictures were projected. A $350 Gramophone-Grand talking machine, one of only three in the state, provided music, except when a pianist played for a singer if a particular song was featured in a film. Mrs. Sloan was in charge of the machine, and she employed a female cashier who also operated the projector and a boy to pass out handbills when the program was changed. The Gramophone-Grand had a brass horn five feet high, and the marches, waltzes and two-steps she played on it helped attract people from the street.

Mrs. Sloan had an associate named McConahae of whom not much is known. However, eventually they owned theaters in Seattle, Spokane, Portland and Victoria, British Columbia. They were considered to have started the first movie theater chain in the country.

The projector, or cinematrograph as it was called, and the films shown came from France. The films cost between $300 and $500 each. The programs were changed weekly, so this was no small undertaking. Admission was ten cents for adults and five cents for children, and on Saturdays, Mrs. Sloan let underprivileged children in free.

The majority of the movies were what we would call newsreels: the parade celebrating Queen Victoria's fifty years on the throne, fox-and-hound hunts and battleship maneuvers. Practically any colorful pageant, bicycle

performance or scarf dancer was filmed. There was also an occasional movie, such as *Cinderella, Little Red Riding Hood* and *Sleeping Beauty*. The closest thing to a modern movie was a film called the *Astor Tramp*. In it, a tramp somehow gets into William Waldorf Astor's mansion and is discovered by the lady of the house asleep in one of the beds. He is, of course, ousted but the next day has the pleasure of reading about his own escapade in the newspaper. People loved this film, and those that were really popular were held over for a second week.

Sloan and McConahae must have made money, because Mrs. Sloan's son, William, stayed in the movie house business, eventually owning his own chain of theaters. A 1934 *Ledger* article said that his owning 457 movie houses made him the largest theater chain owner in the world.

Meanwhile, the cinematograph had been reworked and turned into a shooting gallery. "Big game shooting in Africa, India, and the wilds of the Northwest is no longer to be one of the joys reserved for the very well to do," the *Ledger* wrote. "The method whereby the patron of the new cinematograph device may shoot at living targets to his heart's content is explained."

The new shooting gallery had three screens: a viewing screen in front and two behind. When a shot was fired, microphones suspended above the shooters transmitted the sound to an operator in a cabin who stopped the film. When the bullet penetrated all three of the screens, the back two moved up or horizontally so the hole couldn't be seen out front. This all happened so quickly that when the screens started up, the shooter was given the impression of a moving animal.

City officials, of course, didn't waste any time in making money out of the growing popularity of the movies. In 1917, Tacoma had eight urban movie houses and ten in the suburbs, all of which paid a flat $75 license fee. Under a new proposed licensing law, they would each pay $25 more. And all theaters charging ten cents for admission would have to pay $150 for a license, those charging fifteen cents would pay $175 and those charging

> **PICTURES OF CLIMBERS**
> Moving pictures of mountain climbers ascending Mount Tacoma the first panoramic view photograph of the mountain climbing ever taken will be made by F.H. Kiser of Portland who, with five experienced assistants, accompanied the party on the regular train. Six machines and about 1500 feet of film will be used.
>
> *—Tacoma Daily News, July 15, 1905*

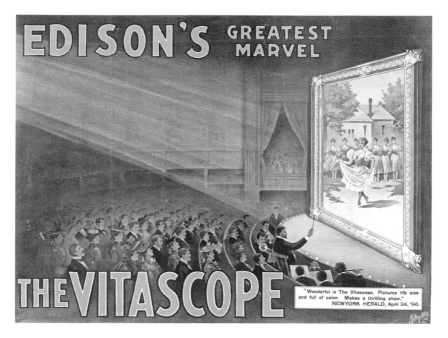

Edison's greatest marvel—the Vitascope. *Library of Congress Prints and Photographs Division [LC-DIG-ppmsc-03761].*

twenty cents or more, $200. Practically all the movie houses would require the highest license because the new feature films were made for showing under advance scales of prices. On the other hand, the vaudeville theater license fee was $150 a year under the new license law, and movie house owners decided there was nothing to stop them from buying a vaudeville license and putting on an act once in a while.

In 1917, the *Tacoma Times* wrote of a proposal to build a million-dollar facility in New York's Central Park that would store "films designed to show future generations how we lived." However, most old films are actually stored at universities.

HARRY MORGAN AND THE THEATER COMIQUE

Mid-thirties, dark-haired with a big mustache and compact body, wearing an ill-fitting suit—thirty-four-year-old Henry Morgan was an enigma. He showed up in Tacoma in 1884 and opened a gambling house called the Board of Trade. "After all," he said, "a town without saloons and gamblers

ain't worth a damn." Outside his establishment, torches set in iron stands on the wooden sidewalk "flickered an invitation to walk through the swinging doors." Inside was a bar on one wall and a small stage nearby. When they weren't hustling drinks, the waitresses took turns dancing—or "entertaining" in one of the several small, curtained "cribs." A barker wearing a derby and checkered vest welcomed men with half a dollar to spend, not to "squeeze the coin till the bird farts and the Goddess of Liberty faints, but to throw the dice and tempt the Goddess of Fortune."

The Northern Pacific Railroad scheduled a stop in Tacoma before it continued north. People often took rooms at the Blackwell Hotel on the waterfront, approximately where the wheat elevators are now, and wandered uptown.

When entering the Board of Trade from Pacific Avenue, men walked into a room with a thirty-foot-long bar. At the back of the room and to the left was a door to a hall that led to the main gambling room. This room was also accessible via a private entryway off Court A. The gambling room was about forty feet by twenty feet and had a sawdust floor. A roulette wheel was against the middle of the north wall. The northeast section of the room was for the faro table. Men played chuck-a-luck, a game in which three standard dice tumbled around in a device that looks like a wire birdcage but is shaped like an hourglass. The apparatus "pivots about its center," and a dealer "rotates the cage end over end." The dice land on the bottom, and bets are made based on possible combinations.

Also available was a game called red-white-and-blue, which may have been one of the newfangled gizmos called slot machines invented by a San Francisco man named Charles Fey. At the Board of Trade, gamblers could also play something called the sluice game or stud-horse poker. In fact, pretty much any game a man wanted to play was available at Morgan's place. Passageways leading to other rooms, poorly lit and poorly ventilated, created a regular labyrinth within the establishment.

Morgan's business was good, and in 1888, he took out permits to build a variety theater, the Theater Comique, adjacent to his gambling hall at 815 Pacific Avenue, where the Olympus Hotel currently stands. The new theater was similar to the Board of Trade, only bigger. It accommodated two hundred patrons and another one hundred in a gallery. Wine sold for between five and fifteen dollars a bottle, beer for one dollar. Women called box hustlers were paid handsomely for what they persuaded men to buy. Morgan's band was considered to be one of the best on the West Coast. To attract a crowd, it played from a balcony over the theater entrance. He paid for quality entertainment, but they

IN CIVILIZED TACOMA

Officer Thomas Desmond, whose beat takes in Opera alley, had heard the screams of a child coming from some indefinite location, several times lately, and started in to find out what was wrong. As a result of his investigations he found a miserable, half-starved dwarf, imbecile child chained up in a dingy and foul basement.

—*Tacoma Daily News*, March 25, 1897

performed in a "rough, barn-like facility with tawdry decorations."

Most of what went on at Harry Morgan's place wasn't legal, but bribes took care of that. While other gambling and prostitution establishments seemed to get raided on a regular basis, it was said that the police were myopic when it came to the Theater Comique. Or perhaps electric bells ringing over the entryway vestibule warned when the police were coming. For whatever reason, few of the claims of swindles, graft and corruption against Morgan ever stuck.

Morgan had few friends, but he was loyal to those he did have. He proved this when one of his "lieutenants" did something the Tacoma police couldn't overlook. The lieutenant was arrested, tried by a jury on which women sat and sent to the penitentiary. Morgan went before Judge John P. Hoyt, called the recent Washington State suffrage law illegal and demanded a writ of habeas corpus. The judge refused; he had previously written a decision declaring women's suffrage valid. Morgan appealed, and two of the three Supreme Court judges who had been against the suffrage act reversed the first decision. It dealt a severe blow to women's rights.

In June 1888, Tacoma residents started an anti-vice crusade. Six days later, an Italian man got in a fight with Henry Jones, one of Morgan's roulette table operators, claiming Jones was "doing him up." The Italian was told to cash in his chips, which he did, and then left after calling Jones a name. Jones followed him outside, and the two started fighting. Morgan's bouncer, a policeman named Cowan, tried to break them up, and Jones threatened to thrash him, too. Seeing the crowd, a second policeman appeared on the scene, and he and Cowan arrested Jones. Morgan immediately bailed him out.

By this time, the *Tacoma Daily Ledger* was so incensed it started a campaign against the Theater Comique and its proprietor. After a series of articles and editorials, Morgan fought back by starting his own newspaper, the *Tacoma Globe*. He hired Colonel William "Lightfoot" Visscher—a Civil War survivor, lawyer and journalist—to run it and J.N. Frederickson to act as editor. The paper was short-lived, but Frederickson lingered in memory for creating the

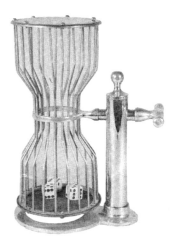

A chuck-a-luck machine. *Author's collection.*

headline "Jerked to Jesus" over the story of a hanging.

The papers called Morgan a Sphinx, and the Sphinx died on April 26, 1895, at his home at 734 Market Street. Sphinx or not, seventy-five carriages made up his funeral procession. Brief services were held at his home at two o'clock, after which the procession left the house, went down Ninth Street to Pacific Avenue and south to Jefferson Street. The Theater Comique band, headed by the procession and followed by the funeral car and pallbearers on foot, walked to the cemetery. Reverend Copeland of the Unitarian church made a short address at the grave site. Back in town, all the saloons closed between two and three o'clock in memory of the deceased.

Court records showed that at the time of his death, Morgan owned, among other things, the theater, a shingle mill at Buckley, a sawmill on Boise Creek in King County and $2,000 in IOUs from Pierce County sheriff Lewis Byrd. Unfortunately, he died without a will, and seven people immediately stepped forward to claim the estate. Eventually, Mrs. Dora Charlotta Morgan was held to be his widow and heir, but after the legal proceedings, all she inherited was her husband's bouncer, Frank "Jumbo" Cantwell, whom she married.

Jump ahead to September 10, 1936, when Tacoma resident William Zimmerman became part of the Federal Writers' Project. According to his reminiscence, the previous spring, City Light began installing underground electric power conduits. Workmen digging a trench in the alley between Pacific Avenue and A Streets at approximately where the Theater Comique stood found a tunnel about ten feet below the surface. It was three feet wide and five feet high and meandered southeasterly toward Commencement Bay, with connecting tunnels. Eventually, it slanted down so steeply a rope was necessary to continue. The "brow of the bluff" was a short distance away.

According to another Writers' Project contributor, "It was common talk on the streets that a tunnel ran from Morgan's place to the waterfront, and that it was used for smuggling Chinese at so much a head, for narcotics, and for shanghaiing sailors."

GROWING PAINS

Abruptly the tide of westward migration, which had reached flood in the late 1800s, reversed in Tacoma. Population ebbed eastward. The little wooden station at Seventeenth was full of people spending their last cash on one-way tickets back to where they came from.
—Murray Morgan

FIFTY YEARS OF HOUSEBOAT LIVING

In Tacoma's early years, houseboats dotted the bay. The papers called them float houses. Samuel Ashton owned one, which he kept tied to a piling a short distance into the bay at the foot of Twelfth Street. Ashton, known around town as One-armed Sammy, peddled candy and sweets at Harry Morgan's Theater Comique when the band played. After he'd earned enough money, One-armed Sammy paid $135 for the float house, which he shared with a friend. But float houses weren't always safe. On February 15, 1890, for reasons never determined, Sammy's house began to take on water through cracks in the walls and through the chimney. Sammy and his friend were in bed and woke when water crept under their blankets. They waded to the door, dove into the bay and swam to a nearby houseboat. Two day later, men brought the house back up, and carpenters went to work cleaning and repairing it.

Puget Sound bathing beauty, 1910 postcard printed by the Central News company, Tacoma, Washington. *Tacoma Public Library Photography Archive.*

FIRST BOAT HOUSE BEING TORN DOWN
PIONEER STRUCTURE ON WATERFRONT GOING.
A floating boat-house belonging to the foreman of the car shops, was stolen from its moorings early this week.

—*Weekly Ledger*, February 23, 1883

In 1890, more than one hundred houseboats anchored where they could (or felt like it) in Tacoma waters. According to the *Tacoma Daily News*, credit for the growth and popularity of houseboats went to the British, who credited them with being comfortable, peaceful due to the boat's motion and interesting places in which to live due to the changing scenery. They were also fairly inexpensive. A good barge foundation ran about $300. A fully fitted cabin was another $200.

Sometimes houseboats were large enough to house a number of people.

In May 1905, a Tacoma detective and a fellow officer, both named Smith, arrested Fred West, a strikebreaker from Montana. The charge was assault with a deadly weapon on a woman named Mignon Guyallme.

It was alleged that Ms. Guyallme had money and valuables in her room. West used what was known as a "heaving lead"—a lump of lead about the size of a goose egg wrapped in hemp and tied off with a rope or something

Teasing the tide. *From* Tacoma Times, *July 16, 1905.*

V EXPENSES FOR THOSE WHO LIVE IN FLOATING HC

:oma Waterfront Brings to Light Many Residents Who Have Selected Their Own
Down the Cost of Living

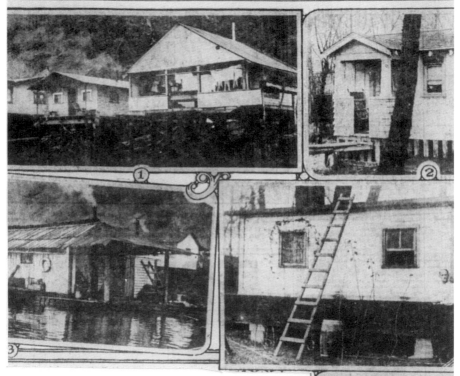

Houseboats save residents money. *From* Tacoma Times.

else that acted as a handle. He got into Ms. Guyallme's room and swung the weapon at her head. She screamed, people responded and West dropped his weapon and fled. The papers don't say, but Ms. Guyallme may have been a lady of the night. She lived in a house in what was known as the restricted area, and West referred to her "a woman of that character." He said it would

BUILT 21 YEARS AGO, AND OCCUPIED BY STANFORD WHITE'S ARCHITECTS.

Down on the waterfront, just south of the 11th Street Bridge, workmen employed by the Foss Boat House Company are demolishing a two-story frame structure. It isn't much of a building as far as appearances go. It is little more than a shack, yet for many years it was as closely identified with the history of the city as any of the more imposing structures that are standing today. It is said to have been the first boathouse built in Tacoma.

—Tacoma Daily Ledger, September 16, 1913

be no crime to kill her. He also claimed self-defense, saying she attacked him with a knife. Now what makes this interesting is that it took the police several days to find West because he hid out on a steamer in the bay that had been converted into a floating hotel for strikebreakers.

At the end of the nineteenth century, houseboats were so common up and down the sound that they were taken for granted and there is little information about them. In January 1895, the steamship *Otter* (said by the papers to be the oldest steamship on the sound but actually the second oldest) was converted into a general trading boat. The Hudson's Bay Company had built the *Otter* and used it in the fur-trading business. During its life as a grocery boat, in addition to canned goods and so forth, it carried chickens for eggs or to be sold live.

On the waterfront below the Tacoma Hotel, a man named E.D. Ferris had a boat-building business. On May 21, 1898, his whole facility was towed to Point Defiance, where it was reestablished and run as a boat rental enterprise.

The following year, the manager of the Old Tacoma Boat Company had the company's houseboat taken off pilings and put onto a float so a tug could pull it to safety. The houseboat had been badly damaged in a recent storm and required repairs.

Not long after that, an Olympia man named Chris Grinrod purchased a houseboat, had it towed from Mud Bay and anchored off shore in Olympia. He painted it yellow to act as a warning, and the houseboat was used as a pest house.

However, most of the information about floating homes comes from *Tacoma Sunday Ledger* waterfront reporter James Bashford. He talked to the

owners of five such homes and wrote a lengthy article. The people he talked to, he said, bypassed architects and began by rolling logs, preferably cedar, from the beach to the water in order to construct a foundation. From there, it was all about what could be salvaged: driftwood, old lumber, old sashes and doors rescued from the city dump. People used any wood they could find for the walls and covered them with tar paper or canvas. Windows went in wherever was convenient and the same for chimneys. Some houses were small. A home in the tide flats factory district measured twelve by twelve feet but also had space outside big enough for a chair and adequate for a dog. The bachelor who owned it positioned his home to avoid floodwaters coming down the Puyallup River.

However, Mr. W.F. Hulbert wasn't worried about the Puyallup's rush of spring water. He built his house sometime around 1911 but did once move it from the west side to the east side of the river because of a troublesome stream on the land above him. He had a neat, small cottage with a small lawn and flowers and shrubs. Mr. Hulbert told the reporter he grew strawberries and grafted trees but probably on land behind the houseboat.

Mr. Hulbert also explained how his neighborhood worked. The city provided a meter and water through what was called a pooling arrangement. Households using the water chipped in to pay the bill, or nearby mills made water available to their floating neighbors. Either way, this water was only for drinking and cooking. Houseboat residents bathed and washed their clothes in river water.

According to Bashford, houseboats dotted the water from the smelter east and up the middle waterway and the Puyallup River. Many of the owners were millworkers, fishermen and people who wintered here and worked in Alaska during the summer. But other houseboats were home to entire families. They kept chickens and ducks and, according to the article, pigs and occasionally a cow. Laundry hanging outside dried quickly. Homes were given names such as Linger Longer, Rest Awhile, Breakers and Do Drop In. Operating costs were almost nil, there were no property taxes and water was often free.

Back then, people had a lot of pride; they wanted to do for themselves rather than accept help, and the Roaring Twenties didn't roar for everyone. Houseboats at least provided affordable homes.

OLYMPUS HOTEL

On May 13, 1906, two men, J.C. Donnelly and Daniel Gamer, announced their plans to tear down the Maze Saloon and the Golden Gate Saloon (the last occupants of Harry Morgan's raucous saloon and fleshpot, the Theater Comique) and build a six-story hotel at 815–17 Pacific Avenue to be called the Olympus Hotel. The Darmer and Cutting Company designed the building. Leopold Schmidt, founder of the Olympia Brewing Company, and Dan Gamer were the builders: O.F. Larson was the contractor and Ben Olson and Company was in charge of heating. The cost was anticipated to be $80,000.

Plans called for a fifty- by one-hundred-foot ground floor with brick and gray sandstone trim in front, the first two stories of cut stone. It was to have 105 rooms, each with hot and cold running water and electric lights. Plans also called for high-speed elevators throughout.

Work began in July 1909 and ended in early winter. The Pacific Avenue entrance opened into a lobby and storeroom. The upper stories had one hundred bedrooms. Several rooms were particularly set up for traveling men. In fact, the whole hotel planned to cater to that class of individual. The basement had a billiards room and rathskeller (beer

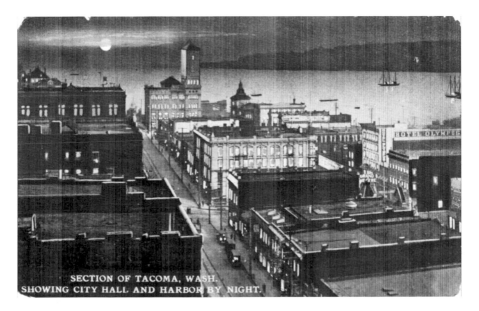

Night scene with the Hotel Olympus on the far right, postcard by Frank A. Nether & Company. *Tacoma Public Library Photography Archive.*

hall). Its "crown jewel" was the 1897 bar, originally crafted in France by Franciscan monks and exported to the Hotel Olympus for the grand opening. Even by modern standards, the bar was impressive: dark wood with carved "wizards' heads"—mysterious bearded and hooded men—the whole piece topped with stained-glass cabinetry.

One of the first stories written in the paper about the hotel was of a baby girl left in one of the rooms.

> While the orchestra at the Olympus café was playing, "Tease Me, Squeeze Me," waiter Constantine Catsampa, caught a hold of Joseph Propper, squeezed him and bit off a portion of Propper's nose. The fight resulted from Propper's failure to pay Catsampa an alleged $10 debt.
>
> —*Tacoma Times*, August 18, 1910

In late November 1911, guests heard a baby crying. Investigators found an infant girl and a half-finished letter. The letter's writer said she was lonely and supposed her husband would be glad to hear from her. People at the hotel said the room was registered to a Miss Gray, a blonde who was last seen leaving around 5:00 p.m. the previous day wearing a black-and-white silk dress and a black hat with a white feather.

As news of the abandoned baby spread, Portland authorities weighed in saying she was most likely Mrs. Frank Bik, who had recently been deserted by her husband and was thought to have been a suicide. Frank Bik had absconded with her savings and that of his father (the two men ran a bakery), leaving her to raise their two-year-old child. However, according to the *Oregon*, the Bik child was a boy. Also, Tacoma police said they thought they'd located "Miss Gray" in a nearby town. Meanwhile, at least a dozen women called the police station wanting to adopt the baby. Unfortunately, the papers didn't follow up on the story.

After only seven years, the hotel needed a face-lift. The bar and an adjacent banquet hall were opened up, thrown together and turned into a social hall with card tables, pool and billiard tables, a soft drinks machine and couches for use by both sexes. The *Tacoma Daily Ledger* said it was the first time in many years that women could be seen standing with men in front of a bar, ordering drinks. Also that year, the hotel had purchased a Model 15, three-quarter-ton vehicle with a white chassis and the words Hotel Olympus printed on it from the J.F. Hickey Motor Company. The vehicle was to transport guests to and from the train station.

The war years were active ones at the Olympus. In May 1917, the hotel got a new manager, Jim Hardy, and within a short period of time the hotel was raided. For many years, traveling salesmen showed samples of their wares at rooms in various hotels around town. At 1:00 a.m., a police captain and several officers entered the Olympus by the front and back entrances and, the paper said, "rushed to the seventh floor by elevator." Just as the elevator doors opened, a phone rang in the room in question, the door to the room opened and several men dashed out and right into the arms of the police. The men weren't salesmen, though. Having finished their business, the salesmen were gone. The officers ended up arresting some local businessmen and the new manager. They also confiscated poker chips and a small amount of money. The police let the men register at the station under aliases but did eventually release their real names. All the men said they would hire attorneys and plead innocent, claiming they were just enjoying a friendly game of whist. Hotel management denied knowledge of the incident. However, four months later, the Olympus was accused of charging more than the Tacoma Hotel did to host dances. The following year, the hotel was raided for disorderly conduct on the part of three women and two men. The *Tacoma Times* implied it was a prostitution sting.

One of the hotel's more interesting incidents took place on August 29, 1936, when a full-grown bear escaped from a park department crate and took off terrorizing crowds of people from Tenth Street and Court A to Pacific Avenue. The animal's attendants "had inflicted wounds on it," and the bear was angry. In the race to escape, the six-foot bear invaded a garage, a bus station and the lobby of the Olympus before joining Ed Cook in the hotel elevator that Cook happened to be operating at the time. The bear stood on his hind legs and waved his paws, with Mr. Cook ducking and weaving until police officer William Nerbonne put the animal out of its pain. It was the third time a bear had terrorized downtown Tacoma.

The hotel ran a soup kitchen for department store clerks and union pickets during the summer of 1937, when Peoples Department Store clerks went out on strike and the other local department stores took the unprecedented step of locking out their employees in an attempt to crush the union. The Tacoma clerks were supported by many local businesses and other unions. In September, management and the union reached an agreement that included a forty-hour work week with time and a half for overtime and an increase in wages for "unclassified" saleswomen from $15.00 per week to $17.25.

Over the next fifteen years, the hotel had a small fire, changed hands and was remodeled more than once. One remodeling project created the

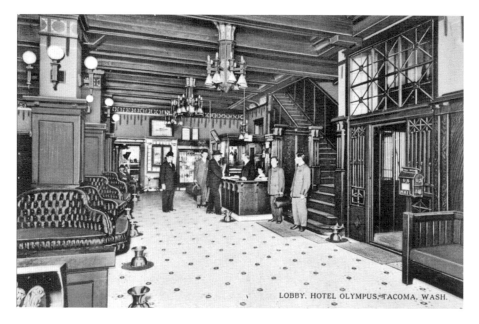

Hotel Olympus lobby, postcard by Curt Teich & Company, 1898 to 1978. *Tacoma Public Library Photography Archive.*

Frontier Room, decorated to resemble a nineteenth-century inn. In 1952, a man named Al Turrill was the manager, and he and his wife and daughters—Virginia, ten, and Deborah, five months—lived in a five-room cottage on the roof. They had summer furniture and flower boxes and thoroughly enjoyed the view. The only problem was that by a city ordinance Mrs. Turrill couldn't hang her laundry outside to dry.

In 1972, the hotel was converted to apartments. Paddy Coyne's Irish Pub was in the building for a few years. In 2004, the apartments became low income. The pub closed, and now the hotel slumbers away on Pacific Avenue, mostly ignored.

PLAGUES AND PESTILENCE HOUSES

Weeks passed with no money in circulation. The grocery stores in many cases set their deliveries on stumps near the stricken houses. Several stores closed entirely. Churches and schools were closed and all assemblages forbidden. Funeral after funeral was held at night.
—William P. Bonney, *History of Pierce County*

Smallpox warning, issued by the Board of Health, early twentieth century. *Author's collection.*

Throughout the 1880s and into the 1900s, cities built pestilence houses, contagious houses or hospitals—places used specifically to quarantine diphtheria and scarlet fever victims and smallpox patients. And where these facilities were to be built was always a bone of contention.

Tacoma had a bad smallpox contagion in the 1880s. Those living here were generally kept at home, and city health officers posted quarantine notices on their doors. However, being a port town, ailing sailors didn't have any place to be cared for. One accommodation was the ship *Alida*, anchored in the harbor. Men stayed there until they recovered or died. The *Alida* was never a "successful" ship. According to a citation from the Tacoma Public Library, "She was out of commission the greater portion of the time after 1879, and in August, 1890, while laid up at Gig Harbor, was burned to the water's edge by a brush fire which swept down from the forest. Her engines were saved in a damaged condition and when last heard, were lying in Lake's shipyard, in Ballard, Wash."

In 1890, when men grading A Street near Twenty-Fifth found a poorly made coffin, six feet long and partially rotted, bystanders speculated about the origins. Some of the conjectures were that the body was a murder victim, that the spot at Twenty-Fifth and A Streets had once been a burial ground for local Chinese or that at one time hands from the nearby Galligher Mill were buried there. However, when one man said the coffin and body could have been relics of an old pest house, fear of disease was so bad, some of the lookers-on scattered in fear of smallpox. The following year, when Saint Joseph's Hospital opened, those with contagious diseases weren't admitted, though the administrator did say no one who was ill would be turned away.

During the summer of 1892, smallpox cases sprang up all over the state, and in Tacoma, doctors began meeting ships coming in to harbor and administering vaccinations to those who couldn't show they'd already been vaccinated. There was still a plan, though, to build to build a pest house in what was called the Fourth Ward, which extended south and east of Tacoma Avenue and South Nineteenth Street. The neighbors, of course, were up in arms, but construction began anyway. It was halted because so few became

ill in Tacoma that year. What had been completed was burned by arson in July.

An amusing thing did come out from that mini epidemic: one of the county doctors demanded the city council reimburse him for the cost of his underwear, for which he was paying the outrageous price of $2.50 a set, and for a new suit every time he attended a patient. The city council felt strongly that the doctor should wear cheaper underwear. The doctor also asked for compensation for a raincoat, and one of the councilmen wanted to know if the doctor wore it to keep germs from reaching his expensive underwear. Eventually, the city paid for the underwear on the grounds that after each visit the doctor had to burn his clothes. Interestingly, the newspaper doesn't say if the city paid for the suits.

JAP LEPER TO BE PUT IN A CAGE

When K. Takuda, the leper confined in a tent at the Tacoma contagious disease hospital starts on his trip back to Japan, deported by the United States, he will be handled as though he were a man-eating animal.

The U.S. Immigrations officers are preparing a large steel cage for the leper. He will be put in the cage at the hospital, carted to the dock, and the cage will be hoisted bodily to the upper deck of the steamer that will take him across the Pacific. The Jap will be exposed greatly to the weather but the government will take no chances of his coming in contact with anyone.

–*Tacoma Times*, June 11, 1914

In 1912, Tacoma finally did get a pestilence hospital. It was built at the corner of South Thirty-Eighth and Warner and opened on December 14. The site was considered convenient to ambulances and streetcars but removed from general traffic. Built at a cost of $10,000, it was said to stand like "a pretty colonial bungalow with wide verandas on the crest of a ridge commanding a fine view of the city and mountains."

The building was divided into separate sections that at the time were for diphtheria and scarlet fever patients. White enamel single beds, iron cabinets and small rag rugs on cement floors made up the furnishings. Windows swung out, and the window ledges had rounded corners and were slanted, all in the interest of keeping the rooms "freed from the deadly germs against which the fight in a contagious hospital must be continuously waged." Also, at that time, the prevailing philosophy for tuberculosis treatment was to keep bedridden patients in well-ventilated rooms.

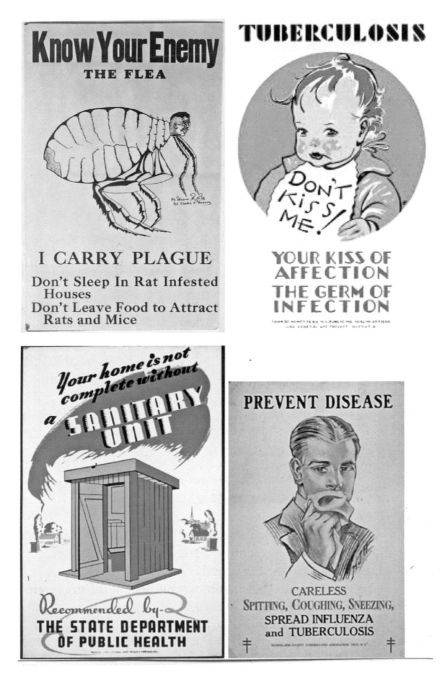

Assorted warnings for prevention of tuberculosis with an ad for a "Sanitary Unit," aka pestilence house, in the lower left corner. *Author's collection.*

The hospital's matron, Mrs. Fletcher, drew up the general plan "for a hospital which," she said, "can be cleaned with a hose." Initially, the building was steam heated; only the kitchen was wired for electricity. Electricity and an addition came to the hospital in 1918. So, eventually, did "diseased women."

The new 160- by 35-foot addition replaced a detention facility that had formerly been in the Municipal Dock building. True to form, the cost of the addition ran to three times the amount budgeted. Plumbing and bars for the windows apparently added to the cost overruns. The *Tacoma Daily Ledger* somewhat casually mentioned women's internment. However, the War Department demanded that the men training at Camp Lewis "be protected from social diseases."

Depending on who was Tacoma's mayor, the detention station was an off-again-on-again affair. Finally, in 1927, overcrowding in the women's jail lead to the detention center's being reestablished, refurbished and budgeted for. Meanwhile, the Public Health Committee met at the Winthrop Hotel to consider how to best spend the city's public health dollars. Members decided that nurses working for a city clinic under the supervision of the Tacoma Public Health Nursing Association would be more efficient than maintaining the old pestilence hospital. Though there was no vaccine for scarlet fever, a smallpox vaccine had been introduced in 1798, and diphtheria immunization had been around since the 1920s. Starting in 1933, Tacoma went twenty-six months without a case of either. A good portion of the nurses' time was therefore allotted to tracking down the sources of various tuberculosis cases.

In 1937, twenty-five years after it was opened, the entire contagious hospital was closed. However, because tuberculosis continued to be a problem, mantoux skin tests to detect the disease in high school students began in 1936.

In 1943, during the years of Roosevelt's alphabet agencies, the WPA leased the hospital building for a short time. Then the city acquired the lease with plans to convert the premises to housing for war workers. A Coca-Cola Bottling Company took over the buildings in 1948. These days, distribution of Kindred and Food Products is handled from the site. How much, if anything, of the original building is left isn't really clear.

Weather, Wells and One Big Hole

After repeated trials and failures, that weak-minded weather-cock on the church steeple at last came to the proper position, yesterday afternoon; but just about that time the wind shifted a quarter, and now the poor thing has lost all ambition and won't point any way.
–Tacoma Herald, *November 3, 1877*

Within days of the above, the *Herald* followed up with why the weather vane was having problems. "It appeared," the *Herald* said, "that the vane on the church steeple has lost its reckoning, and hasn't enough loads in it or something." Apparently, the heads and tails were even; while one end of the directional pointer wanted to go one way, the other end preferred the reverse way. As a result, the vane just didn't move at all. While allowing that the vane was pretty, one of two things would have to be done: either a rod needed to be run inside the spire so the vane could be set every morning, or the sexton would have to climb up to the roof and set it every day and position it using a compass.

Meanwhile, in June 1890 (some records say 1887), John T. Willis was digging a 105-foot well on property he owned at what were called Tyler and Boulevard Streets. The well happily provided water until December 3, 1890, at which time it went on a musical toot and threw out an odor of gas. By that time, Henry Lobe owned the property, and the address was 3309 North Mason Street. Lobe sent word to Major Stam, a real estate salesman for Allen Mason, and the major not only went to see, listen and smell for himself, he also hired a gas expert to investigate. Stam rigged up a whistle on the well, but the noise bothered the neighbors so he removed it. When active, small, up-blowing cyclones formed, they brought up sand, soil, water, gas and air and made a noise so loud it frightened Mrs. Lobe. Stam estimated that the wind's velocity sometimes reached forty miles a minute and that the force was irregular, but when he threw his hat in, it "refused to descend."

Speculations, of course, ran wild. The major thought the air might have "come up through the water" or that it entered through a shaft inside the well above the water. Some speculated that a gas well had been struck. One man said "that perhaps some hustling real estate dealer had fallen into the well and his lungs were just beginning to expand." While Stam poo-pooed this idea, he had no comment on Lobe's theory that the well was "connected with Mount Tahoma."

In digging a well on the property of F.S. Sahm's property on the corner of Yakima Avenue and 21st Street, the workmen came across a good size live lizard. How the reptile came there cannot be conjectured.

–*Tacoma Daily Ledger*, October 3, 1883

For the next year, the well behaved itself. Then Tacoma had an earthquake, and the whistling began again. This time, the well was sucking air in so strongly that Mr. Lobe was barely able to pump water. In May 1893, when a *Tacoma Daily Ledger* reporter was back out to check on the well, neighbors said it had been moaning, whistling or tooting on a regular basis since the earthquake.

Dr. C.P. Culver, one of Tacoma's five meteorologists, appointed by the executive committee of the chamber of commerce, was called in to investigate. He thought the well was connected with a distant cavern by means of a crevice somewhere below ground. He thought that when the air pressure over the mouth of the cavern was heavy, the well whistled, and when the pressure was released, the well sucked air in. In other words, "The well," he said, "is acting as a barometer. With a falling barometer, it blows and with a rising barometer, it sucks. The weather forecasts Mr. Lobe and others made from the well have been fully as accurate as my own during the past winter, the only difference being that the well may not be as sensitive to atmospheric conditions as my instruments."

And that was the last that was heard about the Mason Street well.

Dr. C.P. Culver was actively involved in charity work, and the instruments to which he referred were a full set of metrological instruments he received, also in 1890, to be mounted in an observatory on the top of the Gross Building.

On April 18, Dr. Culver received instruments made by the Henry J. Company. According to www.green.ftldesign.com, "It was safe to say most of the barometers of scientific interest made in the United States between 1840 and 1940 were made by this company." The "observations" Dr. Culver would be reading every day at 2:00 p.m. included "temperature, wind direction and velocity, precipitation, and something called phenomena of weather." He was also to make note of climatic effects on the health, disease and soil in different parts of the state. Tacoma and San Francisco would exchange information about the weather via telegraph. Locally, meteorologists used flags to give people forecasts. A white flag

Woolen Fabrics,
Silks,
Wash Goods,
Hosiery,
Fancy Goods,
Toilet Requisites.

MEN'S AND B
Clothing,
Hats and Ca
Furnishing G

Take Elevator f
LADIES' AND M
Coats, Dresse
and Wrapp

Carpets and Drap

GROSS BROTHERS,

e Agents for Butterick's Patterns. Sole Agents for the Most
Celebrated Gloves, Hats and Ladies' and Gents' Underwear.

901, 903, 905, 907, 909 C S

Above: Gross Brothers at 901 Pacific Avenue, with the weather flag blowing to the south. *Author's collection.*

Left: Dr. C.P. Culver's weather flags. *Author's collection.*

meant fair weather, a blue flag meant general rain or snow, a blue and white flag meant local rain or snow, a white flag with a black center meant a cold front was coming and there was a triangular black flag. If placed above one of the others, it meant warmer weather and if placed below meant colder weather. Gross Bros. Store was considered to have been very enterprising in allowing the weather station to go up on its roof. People had to look at the store to see the flags.

> **U.S. BUREAU AND INDIAN WEATHER LORE DISAGREE**
> Every Tacoman has heard of the wonderful feats of weather forecasting done by the old men of the Puyallup tribe, how the Indians can foresee a long, cold winter when the clams burrow deeply into their mud-shore homes.
>
> —*Tacoma Times*, February 1, 1916

The first mention of a well in Tacoma was the well at the home of Samuel and Isobel Wilkeson at 626 Broadway. As much as we know about it is that it was thirty-seven feet deep, and every morning the Wilkesons would draw up buckets to fill twelve tubs. In the evening, they used the water for their plants. At that time, most people in Tacoma got their water from Tom Quan, who carried it from a spring at 509 Dock Street and delivered it from a mule-drawn wagon uptown. Until the city found a clean, reliable source of water from the Green River, wells were dug everywhere, at South Tacoma in particular. In May 1906, Tacoma faced such a severe water shortage, watering lawns in some parts of town was restricted to an hour in the morning and one in the evening. However, another hole that was not a well being dug at Thirteenth and A Streets was more interesting.

Three years earlier, a man named W.G. Denny had a contract to excavate a 120- by 115-foot space, removing some 6,500 yards of dirt so streetcar barns could be built. The facility was to have sleeping quarters for the men, a storeroom and pits for the cars. When it was done, the old car barn would be turned into a repair and car building shop. Trouble came from two sources: the property was close enough to other businesses that blasting powder couldn't be used, and the men digging ran into a forest of giant tree stumps with roots, deep down, still in existence. One paper called the trees monarchs, and men had to dig them out by hand. As they did, they found arrowheads. At the time of Tacoma's Big Dig, the city was barely thirty years old, but it appears few residents remembered the original old-growth timber.

WEATHER AND ELECTRICITY

A day or two ago it rained all day. A plumber's apprentice got on Street Car #12 carrying a piece of iron gas pipe. He seated himself in the rear and began squirting tobacco juice on the floor. Presently he touched the gas pipe to the iron brake. The passengers positively state that at the same moment the would-be plumber's head struck the top of the car and a blue flame was seen to issue from the top of the switch box under the boy. The boy was in no way hurt except the back of his pants were burnt. He borrowed a newspaper and carried it behind him.

–*Tacoma Daily News*, October 9, 1890

In 1906, a well was created at East Twenty-Seventh and I Streets, mainly because water was found under the business there, but by this time, the papers weren't reporting on wells, springs or weird holes.

WHEN STOMACHS ROSE AND FELL WITH THE TIDE: GEODUCKS

Puget Sound has two claims to fame: two natives that aren't found in many other places—madrona trees and geoducks. The name "geoduck" is believed to come from a Nisqually word, *g*ʷídəq. It is either composed of two syllables, the first of unknown meaning, and the second of *əq*, meaning "genitals" (referring to the shape of the clam), or from a phrase meaning "dig deep." According to Wikipedia, geoducks are sometimes known as "mud ducks, king clam or, when translated literally from Chinese, the elephant-trunk clam." In the nineteenth century, there were many spellings: gweduc, gweduck, geoduck, goaway and goiduck. Locals argued about the correct spelling of the mollusk, with newspapers from as far away as Yakima weighing in. In 1911, pioneer settler Charles A. Burr, who as a child played with the local Indian children, said he would swear an oath that the spelling was gwyduk and people should take his word for it. He added that the spelling geoduk, "geo" from the Greek for earth, was proof that North American Indians were of European origin, hence the similarity in words. However, six years later, to settle what was still an ongoing dispute, the *Morning Olympian* called

on the well-respected and best-known Puyallup Indian, Henry Sicade, to weigh in. Henry had a history worth noting. He was born on February 12, 1866, in Pierce County and left the area to attend a trade school in Oregon. He went to college in Oregon and finished four years of coursework in three. Doctors advised Henry to spend a lot of time outdoors. The life of a cowboy seemed to fit the bill. Henry worked several years as a cowboy in eastern Washington, Idaho and Montana. One story has it that Henry rode for a while with Calamity Jane and her gang. But back to the subject at hand— he said, categorically, that the correct selling was gweduk, derived from the Nisqually language and meaning "dig deep." As recently as 1941, people were still arguing over the spelling.

Pacific Northwest geoducks, *Panopea generosa*, are native to the west coast of Canada and the northwest coast of the United States—primarily Washington and British Columbia. (A related species, *Panopea zelandica*, is found in New Zealand.) According to a 1912 newspaper article, the Seattle tidelands were once salted with geoducks, but after those were sold, none were ever found there again. And also according to old newspapers, Olympia wanted to claim exclusivity on the giant mollusk. At an Elks feast there in 1912, the meal consisted of geoducks in chowder, stewed and in croquettes.

Three days before the banquet, and in order to get enough geoducks to feed everyone, the Elks members formed bands of hunters and to go out and dig. One group returned with twenty, but the other two were skunked

BIG CLAMS FOR NEW YORK
Sickels Told a Tall Yarn at Lotus Club
And Has to Send for a Box of Geoducks to Back Up His
shattered Reputation—Forwarded on Tonight's Train.
Some time ago Avery C. Sickels, who is in New York where all western men are naturally or unnaturally looked up as either natural born liars or successful graduates in the art, [was] to expatiate on the merits of the Puget Sound "geoduck,: 'geoduck.' or giant clam. His talk caused a pleasant smile to go around. He boldly took the bull by the horns and said he could produce the clams. Mr. McIntyre of the Tacoma Fish Co. packed them in ice and Sickels will be in position to make the skeptical lord high chamber of the Manhattan crowd "acknowledge the clams."

—*Tacoma Daily News*, December 16, 1898

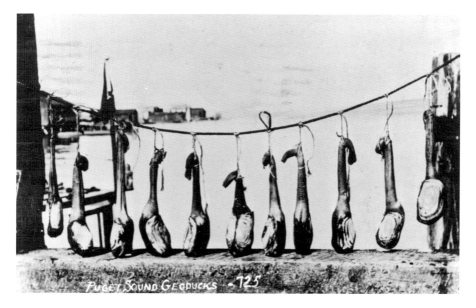

Puget Sound geoducks, 1947 postcard. *Tacoma Public Library Photography Archive.*

and came back with nothing but blisters from digging. Anyone who brought back a horse clam by mistake was fined by the club. Twenty wasn't enough, so members went out the following day, but almost no one was successful. The day before the dinner, the teams were back at it and returned with enough so that the feast, which 150 people attended, was considered to be a big success. In addition to the above-mentioned chowder, etc., chefs fried the meat, boiled it, baked it and served it on the half shell, which didn't go over well. As the plates and platters of geoducks were being carried to the dinners, an orchestra played "Hail to the Chef" and followed that with "See the Conquering Hero Come." When the meal was over, it came out that the majority of those attending had never dug, seen or eaten a geoduck.

Other than sea otters and dogfish, which are able to somehow dislodge geoducks, and starfish, which attack and feed on the exposed siphon, adult geoducks have few natural predators, which may contribute to their longevity. They are one of the longest-living organisms in the animal kingdom. The oldest recorded specimen was 168 years old.

In July 1946, Olympia held the first ever "Gweduc" Derby. The winner (or, perhaps, loser from the geoduck's point of view) weighed five pounds, fourteen ounces. And people were still arguing about the spelling.

MRS. ELMORE SEEKS DIVORCE

Her husband, C.D. Elmore, is Restrained by the Court from Interfering with Her.

Alice Elmore has brought suit for divorce alleging cruelty, unfaithfulness, quarrelsome disposition, and charging his with striking her.

—*Tacoma Daily News*, January 18, 1905

FATHER KIDNAPS THREE OF HIS CHILDREN

Sensational Incident in the Elmore Divorce Proceedings.

Officers Succeed in Locating Him and Restoring Little Ones to Their Mother.

—*Tacoma Daily News*, January 19, 1905

C.D. ELMORE ARRESTED

Is Charged with Violation of Compulsory School Law

On a charge of not sending his boy to school, C.D. Elmore, a well-known contractor was arrested today by truant officer Hill.

—*Tacoma Daily News*, May 4, 1906

THE GRAVEL PIRATE: C.D. ELMORE DISHES THE DIRT

In his autobiography, *The Gravel Pirate*, C.D. Elmore says he was born in 1886 and came to Tacoma in 1889. He said he worked as a house mover and wood deliverer, during which time he came up with the idea of substituting gravel and sand as a less-expensive alternative for crushed rock in cement. If one believes Elmore's dates, it means he began working at age four. Newspaper articles say he was born in 1873 and that he came here with the idea of developing a colony based on a staunch abolitionist and Christian Scientist philosophy but that the colony never materialized.

Since Elmore also believed in the "divine rites of sand and gravel moguls" and wanted to "perpetuate his memory through sand and gravel" he started a business at East F (Tacoma Avenue) and Delin Streets.

There he spent $1,670 having a tunnel dug that would carry away the water he used to separate dirt and debris from his crushed rock and gravel. When city officials found out about the illegal tunnel, they took Elmore to court, spending $450 in fees to try to stop the digging, but they were too late; the deed was done. According to Elmore, several years later, when he lost his business, the city kept the tunnel for its own use.

The city also went after Elmore for unpaid utility bills. Officials said his meter suffered from "industrial

THE GRAVEL PIRATE

BY C. D. ELMORE

The Only Real Book Ever Written
and Published Exclusively
by Home Talent
in Tacoma

HISTORICAL, INSTRUCTIVE, HUMOROUS and
PATHETIC • • ABOUNDING IN TRUTH
WHICH IS STRANGER THAN FICTION

Published by the
WESTERN BLANK BOOK COMPANY
TACOMA
In the year of our Lord 1911

The cover of C.D. Elmore's book with his notation, "Published Exclusively by Home Talent in Tacoma." *Author's collection.*

accidents," a different one every month, and as a result, Elmore never paid a monthly bill more than fifteen dollars. Elmore responded by producing data showing that the city was wrong; but when he was low bid on a project to build a retaining wall on F Street, the Streets & Alleys Commissioners refused his bid and asked for new ones. A company named Thompson & Langford won and subcontracted the work to Elmore.

Elmore says an architect drew up the plan; the Streets & Alleys Commissioners accepted it and approved his materials. He got a $1,500 bond and put up a 175-foot-long retaining wall that ranged in height from 12 feet to 51 feet, spending $5,000 on the construction. Unfortunately, the wall collapsed, and Elmore, held responsible, had to cover the costs. His question, "Why isn't the bond holder responsible?" was ignored.

Elmore's F Street property was across from land owned by a man named Aldrich. The two went together and got a bid to do some grading, using plans provided by the city. While waiting for the plans (which he never got), Elmore started work, selling the gravel generated from the dredging.

When the sales came to their attention, city officials sued Elmore for $1,500. Elmore said he was just doing the practical thing. Was he supposed to find a gulch somewhere and dump the gravel? Since the city was filling in gulches at the time, maybe so.

Elmore's next incident occurred when he got a contract to do some excavating and blasting under the supervision of Nelson Bennett, the man responsible for the Stampede Pass tunnel. There was a restraining order against Elmore, but Nelson became the court-appointed guardian on the project and bondsman Peter Sandberg gave the okay. Unfortunately, Elmore blasted out an entire building front along with the road. Though he claimed over-strong nitroglycerine in the blasting powder, Elmore was blamed, and Sandberg made him pay. Elmore ended up borrowing money

from Sandberg, describing the deal as a "deviation from Sandberg's usual business of running houses of ill repute where he trafficked liquor." Elmore used his home and other property worth $10,000 as collateral. He then bought a team of horses, harnesses and rig from Harrison Bros. for $550 in exchange for $1,850 worth of material and labor. Harrison Bros. paid Elmore $361 and the rest to Sandberg to help reduce the money Elmore owed him. Sandberg, in the meantime, sold all Elmore's collateral property to a competitive business.

With the F Street business gone, and full of disgust for Tacoma politicians, Elmore decided to start over at a piece of land he owned at Midway. There, someone (and Elmore blamed county officials) had been stealing dirt, leaving behind big holes. Elmore built fences, but they were knocked down. County commissioners got on him for the illegal holes.

As his businesses continued to decline, Elmore blamed it all on starting too many of these projects on Fridays, an unlucky day on which to start anything important (Florence Harding, wife of future president Warren G. Harding, felt the same way). Elmore also said that, phrenologically speaking, his head bumps were against him. They showed that gallantry rather than common sense was his primary concern.

Whether he was a victim of city politics, a wheeler-dealer or just stupid is pretty hard to say, but Elmore had the last laugh when, in 1911, he wrote a tell-all book, which he described as "instructive, humorous and pathetic wherein truth is stranger than fiction."

ENTREPRENEURS

Throughout the early 1890s, the *Tacoma Daily News* ran two related stories: "Prizes on Patents: How to get 2,500 For Nothing," and "Patents—Notice to Inventors: There Never Was a Time in the History of Our Country When the Demand for Inventions Is as Great as it is now."

Somewhat contradictory and again according to the *Tacoma Daily News*, in a November 20, 1895 article, nearly 90 percent of all inventions failed to make money for their creators. Nevertheless, the 1890s were an age of inventions. The Cathedral on Wheels was one.

Artist Albert Bierstadt came up with the idea of taking two streetcars with sides that swing out, joining them together and popping out a steeple that was on a telescope. "It could," he said, "be taken to out-of-the-way

ALONG THE WATER FRONT
A device, which would have been of inestimable value to steamboat captains on Puget Sound during the heavy fogs of the past month, has been invented by Captain Solin Salmond.

The construction of the instrument gives the officers on the bridge or poop of a sailing ship a powerful megaphone at hand…If it is the whistle of an approaching vessel he can ascertain on which bow she is approaching and make his movements and signals accordingly.

—*Tacoma Daily News*, December 28, 1898

places that lacked a church, and would be of particular use to missionaries in Africa."

Another streetcar invention was the combination hearse and coffin transportation vehicle. "Its special purpose is to effect economy in funeral expenses," explained inventor Renben McCauley. He took an ordinary streetcar and created a burial casket holder on the roof. The vehicle could carry the casket on top and mourners inside to the grave site, thus saving money on the need for two vehicles. Once at the graveyard, and using a chute and tackle device, the coffin was slid to the ground.

One invention of particular interest to travelers was the railroad bath car. The bath car had double rows of small rooms, each containing a tub. Hot water came from a tank on the car roof. Another idea for travelers, thankfully never used, was the plan for passengers arriving at their station to leave the train by jumping into a large swing or, by the same token, jumping from a swing into a train when headed out. Time was money, and if trains didn't have to stop to drop off or pick up commuters, the railroads would save a lot of money.

Tacoma resident Martin Rosenbaum came up with the combination bedroom set and show table for traveling salesmen. During the day, the setup provided a large table where salesmen could display their wares. At night it converted into a bed. He planned to sell it to hotels and boardinghouses, he said, as he made plans to go east and market the product.

John McGhie of the Tacoma firm McGhie & McCormick developed a cooling room in which to hang slaughtered beef. At his East Twenty-Sixth Street abattoir on the Puyallup reservation he built such a room, using a large fan to circulate air and reduce the temperature. After a cow was killed, he hung the carcass in the cooling room to keep until it went to a retailer.

HE'S A WONDER---THIS BOY!

No overtime for this city hall employee who only "works by the clock." His jury-rigged equipment dropped his hat on his head at quitting time. *From* Tacoma Times, *October 1, 1917.*

McGhie claimed the beef in his room had a better taste than those that were frozen and thawed.

An unnamed chef in a short article labeled "Latest Invention of Chef" came up with his own idea. He cut a small hole in a watermelon and hollowed it out. He filled the interior with chicken breasts, squab legs, Chinese mushrooms and sprouts and then plugged the hole and boiled the watermelon for two hours. The melon meal-in-one was served with the hole still plugged.

After the famed Polish pianist and statesman Ignace Paderewski played in Tacoma, he went to D.S. Johnston & Company, a piano store, to look at the key warmer and tone preserver, invented by an unnamed (as they so often were) Tacoma woman.

The device was intended to keep the keys at any temperature desired, regardless of the local temperature and humidity. Its heat would prevent the strings from rusting and would do away with any damage resulting from dampness. No word on what he thought of the invention.

E. Niles, special agent and adjuster of the Union Insurance Company of California, wrote to W.E. Sharps of Tacoma's Adamant Plaster Company regarding the fire-resistant qualities of the company's plaster: "Its fire-resisting qualities (in the January 4, 1890 fire at Fannie C. Paddock Hospital) were very clearly shown by this severe test, and we desire, in behalf of the companies interested, to express our appreciation of the merits of your invention." Mr. Sharps had the letter published for advertising purposes.

For years, the deplorable state of Pacific Avenue was well known. One day, a newspaper reporter was standing at the corner of Fifteenth and Pacific wondering how deep the mud was when he noticed a man carrying blocks, each about the size of a cigar box and each dangling from a cord on the other side of the street. The man dropped one of the blocks in the muddy road a foot or so ahead of him, and as he left the sidewalk, he stepped on it and dropped the other block ahead of him. Then he lifted the first block and dropped that one ahead of him. This way, he crossed the street mud free. The reporter thought it was an idea worthy of a patent.

Puyallup resident George Roberts came up with an instrument that would speed up the process of cutting shingles. Another man named Roberts had patents on his steam track layer, and the railroads showed a lot of interest

T.A. Ward's advertising wagon. *From* Tacoma Daily News, *October 5, 1895.*

in the curved steel spring and flange device Tacoma weatherman C.P. Culver and his daughter Cecilia designed to reduce accidents. However, one of the most interesting inventions to hit Tacoma streets was the Rotary Advertising Wagon.

T.A. Ward of Tacoma had the wagon made locally by the Fawcett Wagon Company. Advertisements were printed on the sides and ends of the wagon and on a strip of canvas 175 yards long. The canvas was wrapped round cylinders inside the wagon, and as a man drove, the canvas moved along one side and then across the front, along the other side and across the end, giving onlookers plenty of time to read the ads. Mr. Ward's own company used the wagon and bought a team of what sounded like draft horses to pull it. To arrange for advertising or just to see the wagon when not in use, Mr. Ward kept it on display at his 1129 Railroad Street facility.

In an era when bicycles were finally perfected so riding them was actually comfortable, there were water cycles—a bike mounted in a boat and ridden in the normal way but with gears attached to underwater paddles. Peddling pushed the propellers like the paddle boats available for rent at parks.

There was also the ice cycle. It had toothed wheels, but for riders too lazy to peddle, a small windmill connected to the gears and pushed the bike.

And finally, some bicycle authorities thought the epicycle would replace the traditional bike. An epicycle had one large wheel in which the rider sat and used small pedals to activate a little wheel. Gears in the small wheel made the large wheel move. Some patented epicycles had a twenty-foot diameter.

In 1921, Nicholaus Haering's self-service grocery stores were big news in Tacoma. As Haering told a *Tacoma Sunday Ledger* reporter, when people came to one of his stores, they were given baskets and then roamed around, seeing all the merchandise of which they were previously unware, something that made them buy more. A floor manager was on hand to help them find things. Then the customers took their baskets to the cashier, who wrapped the goods and accepted payment. Haering felt this process gave him and his clerks an opportunity to meet the customers and learn their preferences. The idea of self-service grocery stores was only five years old. Piggly Wiggly owner Clarence Saunders started it in his stores. Haering also adapted another idea Saunders practiced: individual packaging. For years in retailing, customers told a clerk what they wanted, and while customers waited, that person retrieved it from shelves behind the counter. The clerk then measured and wrapped up the desired amounts. It was a very social time but also labor intensive, slow and, therefore, expensive. Quite often, stores employed a

Grocery stores go self-service. *Library of Congress, Prints & Photographs Division, FSA-OWI Collection [LC-DIG-fsac-1a34273].*

single clerk who could only wait on one person at a time. So, like Saunders, Haering began having bulk items such as sugar, cereal, beans, rice and peas weighed, packaged and priced at the company's South Thirty-Eighth and Yakima headquarters and from there delivered enough for a week's sales to each of the chain's twelve stores. His philosophy was small profits and quick sales with quality and truth in advertising.

The first years of the 1890s saw a severe and lengthy depression, and the idea of making an easy $2,500 just for having a good idea must have been seen as heaven-sent.

THE KLONDIKE GOLD RUSH
SPELLS DOOM FOR TACOMA

Another $2,000,000 worth of gold is reported from the Klondike by the steamer Garonne *down from St. Mitchel. This sum added to the total of all thus far reported this season will make the output from the northern gold fields something $25,000,000.*
–Tacoma Daily News, *September 13, 1898*

What we call the Alaska gold rush was actually the Klondike gold rush and took place mostly in Canada. An American prospector, his wife, brother-in-law and a nephew were prospecting on Rabbit Creek, now known as Bonanza Creek, a tributary of the Klondike, and found gold on August 16, 1896. Over the next three years, an estimated 100,000, mostly men and mostly Americans, headed to Skagway or up the Yukon River and then on to the Klondike. And in the end, an estimated $29 million in nineteenth-century value was brought out. The trouble was Seattle was the most convenient city of any size for prospectors to outfit themselves and head north and for those coming out of the gold fields to get off ship and spend their hard-gotten gains. As an example: the steamer *Alki* left Seattle in July 1897 carrying more than nine hundred sheep, sixty-five head of cattle and thirty horses, as well as 350 tons of miners' supplies and general merchandise and more than one hundred men. Multiply all this by an untold number of other ships, and it's easy to see why Seattle took off, leaving Tacoma as an also ran.

That's not to say that Tacomans didn't go down without a fight, mostly by becoming outfitters. Businesses such as William E. Erving & Company on Pacific Avenue, Henry Mohr Hardware on Broadway and Charles H. Plass Grocery on Twenty-Ninth and East D Streets, among others, were ready to sell the approximately $1,000 worth of items needed for a season.

Companies were manufacturing specialty items, too. Tacoma Shoe Manufacturing made special "Klondike Footwear," and two companies, the Northwest Manufacturing Company and Edward Miller & Company, made Yukon stoves. Northwest's could be broken down into a compact unit for easy shipping, and Miller's "Brotherhood Klondike Stove" had a detachable

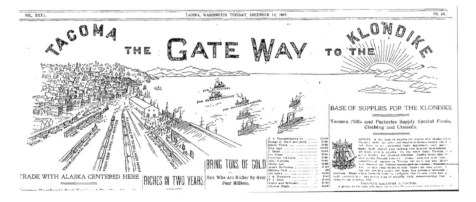

Sketch of Tacoma's harbor labeled "Gateway to the Klondike." *From* Tacoma Times, *December 14, 1897.*

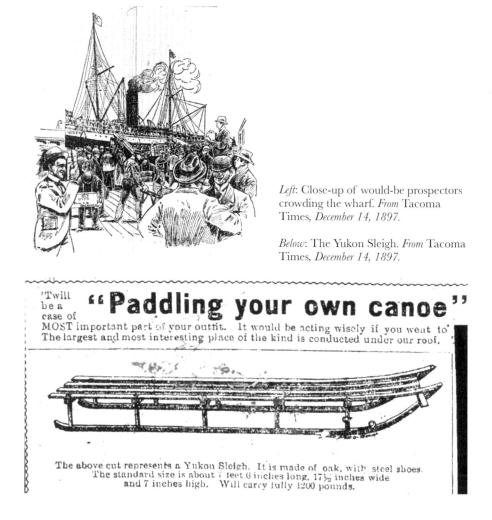

Left: Close-up of would-be prospectors crowding the wharf. *From* Tacoma Times, *December 14, 1897.*

Below: The Yukon Sleigh. *From* Tacoma Times, *December 14, 1897.*

'Twill be a case of **"Paddling your own canoe"**

MOST important part of your outfit. It would be acting wisely if you went to. The largest and most interesting place of the kind is conducted under our roof.

The above cut represents a Yukon Sleigh. It is made of oak, with steel shoes. The standard size is about 7 feet 6 inches long, 17½ inches wide and 7 inches high. Will carry fully 1200 pounds.

oven that could rest on the top or the back of the stove. It also contained sand that, once heated, kept the oven at an even temperature. Homes & Bull Furniture made down-filled sleeping bags, and those from the Alaska Fur Company were made from fur. Three local companies started graveyard shifts to turn out tents and canvas bags, and the Alaska Novelty Company came up with mosquito protectors of fine steel wire net and linen. Local miner J.F. Hardee was given three paragraphs of press coverage for his riffle and self-discharging mining rocker.

Hardee's three-part rocker broke down into a compact twenty- by thirteen-inch, sixteen-pound, easy-to-carry unit. The first part was the foundation; next came the actual rocker with a "stout cloth apron for catching the gold."

The upper part was the box, which had a perforated sheet-iron separator and a riffle and slide in one end that was lifted to get rid of the washed dirt, leaving the gold to fall into the riffle. "A man rocks it with one hand and dips in the water (for dirt, gravel, and hopefully gold) with the other," Hardee said. "Good for beginners."

Sleds, of course, were very important. Tacoma Iron Works contracted with the Yukon International Steam Sled Company to deliver ten twenty-foot-long by seven-feet-wide steam sleds for use on the upper Yukon River, and a steam cable sled for the Chilkoot Pass. The steam sleds had two fifteen-horsepower engines with thirty-five horsepower steam boilers. The power wheel had sharp teeth to grip the terrain. The steam cable sled, which cleared the way for the others, had a snow plow with a circular saw.

HEADLINES

Mad Rush, Halt Called on the Kiondike [*sic*] Stampede.
—*Boston Journal*, July 28, 1897

Pirates after Gold. Chinese Freebooters Are Said to Infest the Waters of Bering Sea.
—*Sun (Baltimore)*, July 29, 1897

Skeleton of Miners Who Perished from Cold, Heat, Malaria or Starvation Strew the Mountain Passes.
—*Morning Herald (Lexington, KY)*, July 30, 1897

Freaks. Alaska Carrier Pigeon Mail Service.
—*Boston Journal*, August 9, 1897

Shot. A Starving Man Was Caught Stealing Bacon from Klondike Prospectors. Black Side Coming into View.
—*Kalamazoo Gazette*, August 30, 1897

Anxiety in England. Fears Expressed That Americans Will Seize the Klondike.
—*St. Louis Republic*, August 22, 1897

Experiments to Be Made with Reindeer as a Means of Locomotion.
—*Age-Herald (Birmingham, AL)*, August 24, 1897

Tacoma Iron Works also contracted to build a seventy-foot stern-wheel steamer to carry passengers, lumber and goods on Alaska's Lake Bennett. The "goods" may have included the three-room, sixteen- by twenty-five-foot portable houses the Wheeler & Osgood Company was making. The houses were constructed out of light, half-inch kiln-dried wood and put together with screws and bolts. In a place where blankets froze to the walls in winter, one wonders how practical these houses were. Or the steamer could have been carrying the sawmill purchased in Tacoma and shipped in December 1897. Prospectors who crossed the Coast Mountains from Skagway or Dyea bought or built rafts at Bennett Lake for transportation down the Yukon River to the gold fields at Dawson City in Yukon, Canada. Thousands of people lived in a large tent city that sprang up on the lake's shore, and the sawmill was intended to "relieve the lumber famine."

And finally, Tacoma's Charles Dupee invented a mechanical device that used oil to melt ice. A tank mounted on wheels held the oil, and bellows or some other type of blower forced air into the tank and through a series of pipes, spilling burning oil on the frozen earth.

Of course, Tacoma had no monopoly on inventions. A number of people thought air transportation to the gold fields was a good idea.

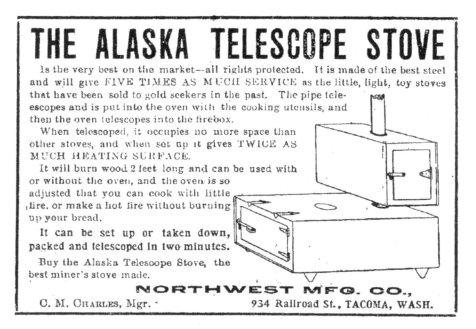

Northwest Manufacturing of Tacoma's Alaska Telescope Stove. *From* Tacoma Times, *December 14, 1897.*

Ottawa's J. De L'Etoile developed a combination canvas, egg-shaped balloon attached to an airship. The balloon had a propeller in front to "cut through the air." The steering mechanism was in the rear. The balloon was supported by a framework of bicycle tubing with a small hollow shaft running through the frame for the gears and power. Gas generated in the "car" inflated the balloon from which the airship was suspended.

The Duluth, Winnipeg and Klondike Balloon Transportation Company thought it could launch a balloon from the top of a building, which would set down at various Hudson's Bay Stores, creating a sort of relay system. Attorney Henry F. Granger of New York described to the *New York Herald* the Klondike Bike that four unnamed investors wanted to build. It was "especially designed to carry freight and was, in reality, a four wheeled bicycle...built strongly and weighing 50 pounds. The tires," he told the paper, "are of solid rubber and one-and-a-half inches in diameter." It had regular frame that "was wound with rawhide shrunk on." Granger was headed west to hire and send north a mining engineer who would buy up all the "promising claims."

Elsewhere, the Cudahy Packing Company of Omaha, Nebraska, shipped up fourteen cars of canned meat. The Catholic Church's Order of St. Ann added eight more nuns to their Mission of the Holy Cross, 375 miles from St. Michael, and the Episcopal Church made arrangements for missionaries to head north. Perhaps of more interest to the miners, though, was South Dakota's L.M. Keenan's project. He scouted the area for "Young Women, Who Must Be Comely and Respectable" to be "Auctioned Off."

> Was It Worth It?
> "Klondike Gold at the Mints. Receipt of $3,750,000 at San Francisco Breaks All Records."
> –*Plain Dealer (Cleveland, OH)*, August 5, 1897
>
> "Piled Like Cord Wood. Yokon [*sic*] River Steamer Loaded with Sacks of Gold."
> –*Kalamazoo Gazette*, August 27, 1897
>
> "Treasure Ship, Portland, Arrives from St. Michaels. Steamer Brought Less Gold Than Was Expected. There Was Only About $825,000 in Nuggets and Gold Aboard."
> –*Oregonian*, August 29, 1897
>
> "A Monument to Human Folly."
> –*Plain Dealer (Cleveland, OH)*, August 10, 1897

Meanwhile, back in Tacoma, Ralph McKenzie wrote to his wife at their home at 2707 Carr Street, saying it was so cold he wore sheep skin on his nose but that he and his three partners "Believe They Have a Klondike Fortune." And Tacoma's B.P.O.E. was going to be richer by way of a set of horns found by local miners under twenty-one feet of ice at Claim No. 10 on Sulphur Creek. They were said to "belong to either antediluvian monarchs of the elk herds roaming the Artic, then a semi-tropical region, or to some other genus bod quadrupeds."

Tacoma's Lafayette B. Smith "came across a full-grown man, dressed in clothes (overalls, a heavy mackinaw shirt, and stout brogans. [With] his hair to his shoulders and [wearing] boots, [standing] in a natural attitude)...a silent statue of stone. At his [the stone man's] feet," Smith said, "lay a gun, an old Winchester, and nearby eight steel traps tied together." Smith denied the *Tacoma Daily News*'s accusation that he might have been dreaming.

William Ewing, a former Tacoma police patrol wagon driver, came out of the gold fields with enough money to invest in real estate. The black man, who headed for Oakland, was judged by the *Tacoma Daily Ledger* to be "one of the richest miners of the Fairbanks country."

But Mrs. William "Ma" Huson might have had the most amusing experience. She and her husband dismantled a piano, wrapped the parts in yarn and took them to Dawson. There, they put the piano back together, and Mrs. Huson made petticoats with the yarn and sold them for $125 apiece.

PART 3

A NEW CENTURY

Mention my name in Tacoma
It's the greatest little town in the world
I know the big shots in the City Hall
They even got my picture on the post office wall.
–Lyrics by Bob Hillard, Dick Sanford and Sammy Mysels

DON'T KNOCK IT: DOOR-TO-DOOR SALESMEN

In Tacoma's early years, most homemakers had little time to be lonely for long; door-to-door salesmen crowded the streets. The merchants didn't like them, the city fathers were on them about licenses and the newspapers were constantly warning women about what the men were selling. "The secret of the fruit peddler" was one warning. Apparently, oranges bought from a door-to-door salesman were cheaper than what the markets were selling, and the paper wanted to know how it was possible. A Tacoma man named S.H. Emerson explained: Riverside, Washington navels, which sold ninety-six for $4.50, were selected in the groves and packed by experts. The peddlers, though, bought oranges that were too small, bruised, had plant rust or were defective. The salesmen cleaned them up and swelled the rinds, though how they did that wasn't explained, and sold the oranges to homemakers looking for a bargain.

Before there was the Do Not Call list, most everyone suffered from cold callers. Before cold callers, there were door-to-door peddlers. In America,

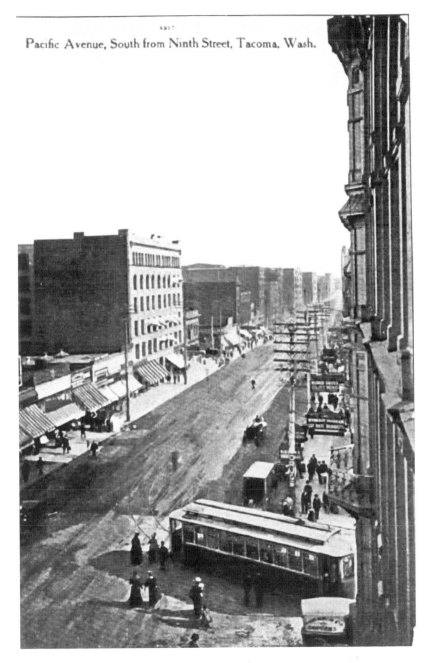

Pacific Avenue, South from Ninth Street, Tacoma, Wash.

A new century: Pacific Avenue looking south from Ninth, postcard circa 1905.
Tacoma Public Library Photography Archive.

Yankee peddlers, either by horse or foot, went door to door or farm to farm. They sold items such as pins, needles, hooks, scissors, combs, small hardware and perfume. Those who walked carried their goods in tin trunks slung on their backs by a harness or leather strap. The more prosperous used wagons.

The December 18, 1898 *Tacoma Daily Ledger* had an interesting article about a door-to-door jewelry salesperson—not particularly unusual except it was a woman. Her calling card read "Miss Blank, Visiting Jeweler."

Like many single women, Miss Blank unexpectedly found herself needing to earn a living. One day she happened to visit a friend who had just inherited a lot of old-fashioned jewelry. Miss Blank said the stones were beautiful, but the settings were clumsy and out of date. So she made some sketches of suggested settings, and her friend was delighted in the pretty and very original designs. According to Miss Blank, the friend declared her a genius and suggested she ask other people to get out their old jewelry so Miss Blank could show them what they could do with the odds and ends to make them beautiful. Needing an income, Miss Blank took her up on the idea.

The women she worked for gave her letters of recommendation, which she showed when introducing herself to various jewelers. Many of them agreed to let her set some of their stones; using Miss Blank's designs and services saved them money. While she worked for the jewelers, Miss Blank studied the various stones and soon acquired an eye for what was good and what wasn't. As a result, she became a broker, helping women buy, sell and exchange their jewelry. She gave the *Ledger* some examples. Mrs. A had opals, which she thought were unlucky. Miss Blank arranged a swap for turquoise from Mrs. B, who thought the turquoise made her look shallow. Mrs. C had one really nice pearl set in a locket and wanted pearl earrings; unfortunately, she couldn't afford a second stone. She did, however, have diamond screw-in earrings that Miss Blank was able to sell and use the money for a second pearl. Mrs. D. had a large outstanding dressmaking bill she was afraid to show her husband. Miss Blank was able to sell enough of the woman's old gold jewelry to pay off the debt.

Now that she was becoming known as a settings designer and a gem broker, Miss Blank decided to offer herself as a jewelry cleaner because, she said, overworked maids didn't have time. Initially, all she did was work the stones over with her hands, but gradually she began studying ancient recipes. Among the recipes she found and used was one from India that advocated polishing pearls with boiled rice. Another was to bake them in dough. The oldest and weirdest involved a rooster's gastric juices. Miss Blank fed a pearl to a rooster, waited two hours, as suggested, and then butchered it. "I felt like

a murderess," she said, "but the pearl was ever so much improved." Real pearls, especially old ones, lose their luster if they aren't worn. Before she disappeared into history, Miss Blank was known for being a pearl doctor.

Door-to-door salesmen were all over Tacoma. In Fern Hill, a Mr. H. Berger made deliveries using a pushcart.

In 1890, Bethany Presbyterian Church began as a Sunday school meeting in the Robert Tripple Residence at 3309 North Stevens. Tripple was a traveling salesman for Van Eaton, Fogg & Co. Shoe Manufacturers.

Colonel Nate W. Flasig, one of the oldest traveling salesmen in the county, was in Tacoma yesterday on his annual tour. Colonel Flasig sells needles for a British firm and has been with the company for fifty-four years. This was his thirty-fifth trip to Tacoma in as many years. [He] is as well known on this coast as any man making this territory.

—Daily Ledger, August 8, 1905

Karolyn & Floyd Piper became owners and teachers of the Honolulu Conservatory of Music and of a music school located at their white frame house on North Second Street. Karolyn was born Karolyn Kimmel in Fargo, North Dakota. When she fell in love with Hawaiian music in the 1920s, Karolyn took lessons at the Honolulu Conservatory franchise owned by Adalia and Charles Casper and began teaching door to door, traveling through storms and snow drifts. The Caspers had opened another Honolulu Conservatory in the Bernice Building, 931 Broadway. Karolyn married Adalia Casper's son, Floyd Piper, and the couple joined his parents in Tacoma and taught ukulele, accordion and guitar.

Ophthalmologist Charles Green went door to door fixing, fitting or making glasses. Green came to Tacoma to work because of the availability of raw materials and good port facilities. He chose to employ local labor and eventually opened Green Optical. The women on the bowling team he sponsored always had the latest in eyewear.

Marcus Nalley worked in a Saratoga hotel kitchen, where he moved from kitchen flunky to pantry boy to fry cook. He became a chef on the first *Olympian* of the Milwaukee Railroad, which ran between Chicago and Tacoma. Later, at Tacoma's Bonneville Hotel, he learned to make a new potato delicacy, "Saratoga chips." They were renamed potato chips, which Nalley cooked and bagged in his kitchen and then hawked to local grocery stores.

Tacoma's Door-to-Door-Salesmen Timeline:

February 12, 1891: Another Guard Needed. Ranchers of the Okanagan who have engaged a man to ride along the river and see what the Indians are doing should employ an Indian to ride along the reservation side of the river to see what the whiskey peddlers are doing.

January 13, 1893: Householders are warned to beware of a man who is selling a powder that "will make gasoline non-explosive and make it burn about eight times longer."

November 10, 1898: Seattle Bacon Peddlers Run Out of the City. It was found the bacon they were selling as Frye-Bruhn's best was evidently something left over from the cheap Klondike stock.

January 9, 1904: Small Merchants. Youthful peddlers aboard the steamship, *Ching Wo*, had and sold goods of every description that would attract the eyes of the Orientals.

August 28, 1909: He Sold Razor Blades at Half-Price. Frank Thomas was arrested for peddling glasses and razors without a license.

July 29, 1910: It Was Such a Good Joke. He was selling toy balloons at 11th and Pacific yesterday and, in making change, his hand slipped and away went his stock. People laughed. No one thought of the peddler's loss.

December 4, 1913: Buy It by the Box. The great popularity of Wrigley's Spearmint Gum is causing unscrupulous persons to wrap rank imitations that are not even real chewing gum. They will be offered to you by street peddlers.

January 15, 1914: The Fishiest of Fish Stories. A fish peddler was hurrying up Jefferson Avenue when the tail-board of his cart dropped off. Fine salmon slid quietly towards the end of the wagon and plumped lusciously into the street.

February 14, 1914: Everybody Has to Light Up Nowadays. If you drive a milk wagon, an express cart, a fish peddler's wagon, a sewing machine demonstration buggy, a surrey, or just a plain, ordinary automobile, you must get the craft lit up at once or go to jail.

The Latvia-born Herman Brown wanted to become a mining engineer. However, his brother-in-law, who was the captain of a windjammer that was set to sail from Amsterdam to Holland and on to the West Indies, persuaded Herman to sign on to his crew. Brown liked life at sea so much that when the first trip was done, he signed on with another full-rigged ship, this one carrying a cargo to Brazil.

In 1907, after years at sea, Herman opened the Union Furniture Store in Aberdeen. He sold out to enlist, ending up after the war in Seattle with twenty dollars in his pocket. A man who came down in history as Mr. Main offered to stake Herman two hundred pounds of dried prunes if he would try to sell them in Tacoma. Herman sold them all in two days, returned to Seattle for three hundred more pounds and sold them in three days. Eventually, he struck out on his own. Herman sold prunes, figs, apricots, dates, peaches and raisins, plus pecans and walnuts; his territory went from Stadium Way to Day Island and from Thirty-Eighth to Point Defiance. He also made selling trips to Raymond and South Bend and, in 1925, started making yearly trips to Idaho and Montana. After World War II, he hired a helper, and they sold throughout Wyoming, Colorado, Nebraska, Iowa, Wisconsin and Minnesota. Herman Brown stayed in the door-to-door fruit-selling business until 1965 and died in 1968 at age eighty-four. He attributed his good health to a sixteen-day fasting period each spring, during which he took in nothing but water, and eating plenty of dried fruits and nuts during the rest of the year.

ALLIGATORS IN SNAKE LAKE AND SOME OTHER SNAKE LAKE TRIVIA

George M. Brown came to Tacoma around the turn of the century, owned the St. George apartments at Ninth and G Streets and had big dreams about the Pacific Northwest's potential and his part in that potential. But Brown was a Louisiana man at heart, and his ideas were all based on his knowledge of the bayous in and around New Orleans.

Prior to his Tacoma days, Brown spent twenty years learning about the Gulf of Mexico's land, climate and wildlife. That resulted in plenty of opportunities to watch alligators. So in July 1907, when Mrs. V. Rohrer, a family friend, was coming up for a visit, Brown asked her to bring him some.

The lady arrived with four alligators: two twelve or so inches long and two twenty-four inches or more. Brown built a reservoir in the backyard of

his South Seventh Street home and turned them loose. There, a reporter from the *Tacoma Daily News*, who dropped by to see what was going on, found the gators basking in the sun—at least, they basked until they caught sight of the reporter. His presence sent them shooting into the murky depths of their pond.

The "saurians," as Brown called them, knew him, he said, but threw fits when strangers approached. Brown went on to say they were generally placid, lazy and harmless and liked to lie with their mouths open and let their meals wander in. Of course, he conceded, it was best for children and small pets to cut a wide berth. But because they were so lazy, the alligators only ate about once every three weeks and so were relatively safe to have around.

Unusual pets, the reporter probably said. But not pets at all, Brown would have explained. His idea was to develop an alligator colony in Tacoma.

"The temperatures in and around the Louisiana swamps sometimes got colder than winter temperatures in Tacoma," he said. "With a nice big, well-protected marshy area, the gators'd do just fine. They'd lay their eggs in the grassy mud and leave the sun to hatch them. Since they lay up to sixty eggs at a time, in no time at all there would be alligators to harvest for their skins."

The reporter also found out that while Brown's saurians were acclimatizing, Brown had been scouting the area for a good place for his colony. In a couple of weeks he figured to let them loose in Snake Lake.

Jump ahead a few years to when Alf West grew up on the lake. West left a short memoir of his years there from 1914 to 1922 and didn't mention any alligators; he didn't remember any fish, either. But if the gators were ever turned loose in Snake Lake and ate the fish, they missed the garter snakes. According to West, the neighborhood was "lousy with garter snakes."

Currently, Snake Lake is described as a remnant marsh from the last glacier period. It's approximately 150 to 200 feet

SNAKE LAKE OUT OF ITS BANKS—RESIDENTS OF SECTION USING BOATS—ASK CITY FOR AID
Snake Lake, a body of water in the West End nearly a mile long and about 400 feet wide, has gone on a rampage during this week's thaw, pouring out of its banks and inundating dozens of yards. Several dwellings are surrounded by water, the basements flooded, and the occupants are forced to use boats or hastily constructed bridges.

—Tacoma Times, February 10, 1916

wide and 3,700 feet long. It may have been bigger in Alf's days. He recalled that though all but a pool of water at the south end dried up every summer, it was still a favorite gathering place for socializing.

At its deepest, the lake was only seven feet, so swimming was limited, and the land surrounding it had been extensively logged in the 1800s. In summer, Alf and his friends spent a lot of time trying to retrace the old logging roads by following the remains of rotted logging ties made of small tree trunks.

In winter, when there was more water and Snake Lake iced over, it was a good place to skate. Summer or winter, it could be dangerous. Alf never forgot two schoolboys who drowned in it.

West also remembered that Snake Lake was where he threw a chicken into the water to see if it could swim, but that's another story.

For quite a few years, the Tacoma Rail and Power Railroad, which started at Twelfth and Sprague Streets, ran through Allenmore, along Center Street and Tyler Street on its way to Manitou and American Lake and followed a track bordering Snake Lake's east side.

Fires and more logging took their toll in the 1920s, but already the Metropolitan Park district had its eye on the land. In 1928, it bought thirty-nine acres of what is now the unique and lasting gift of a thriving nature preserve in an urban environment with nary a gator in sight.

Smuggling, Drugs and Demon Rum

In the last days of the nineteenth century and on through Prohibition, Tacoma, as a port town, was a perfect place for smuggling. Opium was legal and Canadian wool was contraband, but trafficking in Chinese labor was the most lucrative. The Central Pacific Railroad alone had imported more than ten thousand Chinese men to provide cheap and efficient labor. However, their numbers stirred up strong feelings of "American Jobs for American Men." As a result, the Exclusion Act of 1882 stopped Asians from coming in for the next ten years. The law created a highly lucrative smuggling industry.

In 1880, 3,186 Chinese people lived legally in Washington, and their communities served as drop-off sites—places where newly smuggled Chinese could quietly blend into the existing population.

The *Haytian Republic*, which carried both legal and illegal cargoes, was a well-known ship on Puget Sound. When Chinese were expected, small boats masquerading as fishing vessels anchored nearby, and the illegals

CHINESE GUARDED
Three Chinese Locked Up in
Tacoma Today
A Sensation Develops
Bogus certificates of entry have
been on sale at Port Townsend.

—*Tacoma Daily News*, May 5, 1891

were rowed to them. From there, the men were taken to a convenient island. When their numbers were large enough to run the risk, a ship picked them up and smuggled them to the mainland. A favorite practice was for the illegals to disguise themselves by wearing Indian women's garments, which they discarded as soon as they reached a community of their own. However, if before unloading the "cargo" the smugglers spotted small and lightly armed revenue cutters, rumors had it that the Chinese were occasionally thrown overboard and left to swim. The general practice, though, was to drop them off on barren rocks and leave them. A group of picnickers reported the rescue (and smuggling in) of a Chinese man off a place known as Deadman's Island.

One large smuggling ring, whose members included government customs officers and political and financial leaders, operated out of Tacoma. Special investigators busted the ring in 1888, sent a number of the men to jail, and confiscated the *Haytian Republic*. The ship was auctioned off and renamed the *Portland* and in 1896 brought word of and a ton of gold from Alaska. It came to its end stranded at the mouth of the Kalalla River in 1920.

During these years, opium was legal, though duty was twelve dollars a pound. Canadian wool, however, was not legal. In May 1905, the United States government put in effect a plan to break up a wool smuggling ring. While pretending to be seal hunters, customs inspectors Roy Ballanger and F.C. Dean cruised the waters around the Juan Islands, eventually meeting a Shaw Island man named Alfred Burke. Telling Burke they were sightseeing, the customs men hid wooden meat skewers in Burke's piles of fleece. Burke loaded it for shipping on a "difficult-to-see boat" at South Pender Island and set sail for Orcas Island. Ballanger and Dean followed, found the "skewered" wool in a store warehouse and tried to arrest Burke. He evaded charges because they hadn't "actually seen him cross the border," but the wool was seized and Burke lost his profit.

The majority of the smugglers were men, and precious gems were rarely the contraband of choice, but on the train to Bellingham, one day, the conductor suggested to customs agent Fred F. Strickling that he check the shaggy dog companion of a well-dressed woman. The dog was tied up in

Beached—a smuggler's vessel. *Author's collection.*

the baggage department, and Strickling watched it for a while, noticing that it was scratching more than was normal. He checked the animal and found a razor slit in its skin where its owner had tucked some diamonds.

In addition to their illegal occupations, some smugglers worked hard to blend into the community. Lawrence Kelly, a Civil War Confederate

soldier, vowed "never to earn an honest living under the Stars and Stripes." When out on the water, he kept his craft greased with pot blacking and tallow to cut water resistance. But on land, he served on the local school board. Kelly was eventually picked up on a train headed from Tacoma to Portland, returned to Tacoma for trial and sent to the penitentiary. While he served time, his wife sold off pieces of their property. By the time he was released, Kelly was a broke and broken old man. He contacted the Daughters of the Confederacy and spent his final years at a Confederate soldiers' home in Louisiana.

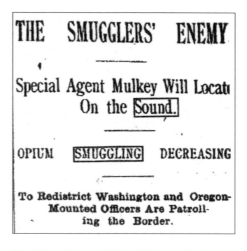

THE SMUGGLERS' ENEMY

Special Agent Mulkey Will Locate On the Sound.

OPIUM SMUGGLING DECREASING

To Redistrict Washington and Oregon- Mounted Officers Are Patroll- ing the Border.

Headline: "Agent Mulkey Takes on Opium Smuggling Across the Border from Canada." *From* Tacoma Daily News, *April 2, 1890.*

Jim "Old Man" Jameison painted his boat green to match the water, but the coast guard spotted him anyway and Jameison spotted them. He then spent twenty minutes dumping $20,000 worth of opium overboard. When the customs men pulled alongside, he said, "It's all right, Captain, I don't need a tow."

Henry "The Flying Dutchman" Ferguson came to Puget Sound from Butch Cassidy's Hole-in-the-Wall Gang, changed his name to Wagner and embarked on careers of both high seas and highway robbery. When sheriff's officers finally cornered him in October 1901, the result was a prolonged shootout. Wagner and an accomplice were taken alive and tried in a Canadian court, and Wagner was sentenced to death. Swearing never to hang, he tried to beat his brains out on his jail cell walls. It didn't work, and Wagner was hanged on August 28, 1913, in Nanaimo.

As the new century advanced, smuggling in Chinese labor was no longer profitable. Not to worry, the government was on the brink of giving criminals new revenue sources: drugs and liquor.

Some businesses benefited from Tacoma's location on Commencement Bay. The Beach Tavern near Titlow on Sixth Avenue regularly received smuggled rum, whiskey and beer, and the Unicorn at 5405 North Forty- Ninth Street in Ruston distributed liquor while at the same time providing

WHISKEY IN WAGON AXELS
New Scheme Devised for Smuggling Liquor.

–Tacoma Daily News, May 3, 1904

entertainment. Drinking clubs at the north end of Pearl Street were considered Slavic establishments. The Toscano Café at Fifteenth and Broadway was for Italians. A still at 1210 North Union benefited students at the College (University) of Puget Sound. In addition to students and foreigners, Tacoma also had a large population of relocated southerners who had great homebrew-making skills. And regardless of the law, many folks weren't about to give up drinking. Pierce County was soon dotted with stills, at least one of which could produce a gallon of whiskey a minute.

In March 1926, two girls bought a car from a man named W.H. Rose who lived at 3611 South Thirty-First Street. The police stopped them because the car had been reported stolen. The girls had all their purchase information, and as a result, the police obtained a search warrant, which Officers Ellis and Hill served on Rose. They found a completed still and one under construction, a condenser, copper sheeting, over one hundred feet of copper coil and a ten-gallon keg of moonshine. There were also car parts scattered around, and though Rose actually did repair cars, it was believed he fenced stolen cars and parts as well. He didn't make the "shine," though. It was a gift from someone for whom he'd built a still and who wanted to share the wealth.

In the case of a bust at 916 South Third Street, it was the fumes wafting around that alerted neighbors who, in turn, alerted the police. When officer Emil Matthies entered the home of Charles Milton, he found a fifty-gallon still, barrels, jugs, bottles, corn, sugar, yeast and barley, plus one hundred gallons of mash and fifteen gallons of "mountain dew" awaiting sale.

When the Dry Squad was out and about, it seemed that no one and no place was safe. Louis Fedeli, a laborer living at 6016 South Tyler, was arrested when 8 gallons of liquor and 150 gallons of fermented mash were found in a hole on his property. Mrs. Agnes Cortez was entertaining a few friends at her home at 2806 South A Street when officers dropped by and seized 7.5 gallons of homebrew. On one Saturday night sweep, officers arrested John King at Fifteenth and Pacific just as he was about to make a delivery and busted a drinking party at 503 South Thirtieth Street where they arrested Joe McCane and confiscated 91 quarts of beer, 10 gallons in the brewing

Making moonshine, from a postcard circa the Prohibition years. *"A Typical Moonshine Still in the Heart of the Mountains" in North Carolina Postcard Collection (P052), North Carolina Collection Photographic Archives, Wilson Library, UNC-Chapel Hill.*

stage and 420 empty bottles. At 5413 South Washington, they found six bottles of whiskey and 35 quarts of beer in a specially built cache under the bedroom floor.

And then there were drugs.

Commissioner John Murray was determined to root out the dealers in Tacoma and improve the town's image. On March 28, 1923, the *Tacoma Daily Ledger* devoted half its front page and part of page four to how the local police broke a big drug ring here. For months, government agents, Tacoma detectives Fred Lomax and John Paulson and local police gathered evidence from up and down the entire coast, identifying dealers in opium, morphine and other narcotics. With that information, the Tacoma police were ready to set up a trap.

First, they found a house and then they found two girls, referred to as Janes, to go undercover. Little was known about the girls, including their actual names, except that they came from a small Washington town and were apparently former addicts who had been hounded by dealers. They said they wanted to get involved in the sting in the spirit of revenge and wanted to break the ring to save other girls.

The house the authorities chose was at 1514 E Street (E is now Fawcett). Over the next few weeks, as the authorities watched, men, including prominent businessmen, snuck down the alley and down a set of stairs, in through a rear entrance, walked through a darkened room, out through a curtain-covered French window and finally into a well-lit room where the two women sat. Dealers came and went watched by so many law enforcement men staked around outside it was estimated one hundred eyes were watching the house. The paper called it the House of 100 Eyes.

Until 7:00 p.m. on March 26, no one other than the evidence gatherers knew a raid was planned. Then word went out that the trap was to be sprung. Police Captain of Detectives John Strickland told the officers to meet him

in ten or fifteen minutes in the city hall annex. Once they were gathered, Lomax and Paulson outlined the plan for the arrests of the men and women for whom warrants had been secretly issued.

The group broke up with Lomax, Paulson, Captain Strickland and police captain Fred Gardner each leading a team. They took up positions at a number of different places. One was between the dining room and a bedroom, where the men put a buffet with a mirror positioned so that with a curtain on one side the officers could stand hidden in the bedroom and see everything going on in the living room. The girls sat in front of the buffet reading.

The evening started with the phone ringing and the conversation centering on "coming up" and "bringing something." Around eight o'clock, the doorbell rang, and the first dealer arrived. He was a black man named Gene Clifford, already known to the police. One of the women questioned him, and Clifford said, "When I does business, I does business and I don't wait for no one." This was enough for United States marshal Frank Burrows, who stepped into the room, and for the police who came out of the bedroom just as Gene started to sit. They took him to the kitchen and emptied his pockets. Gene had a tobacco pouch of narcotics. He started a fight, lost and was taken to jail.

Next to arrive was a suave Greek man named Nick Marras. All the *Ledger* said was that he had started to sit when the officers appeared. Nick went toward them with open arms and was taken to one of the rear rooms. He started pleading complete innocence of any drug dealings and might have gotten away except one of the officers had seen him in the house several nights previously.

Earl Ballard, another black man, came next. He, too, was all smiles and full of hail fellow well met when a back door opened, officers appeared and Earl's *joie de vivre* disappeared. After officers found narcotics in his vest pocket, he said, "Someone has double crossed me for sure. How do you suppose that got there?"

The officers' interest then focused on the next arrival when taxi driver Frank Veasey arrived driving a Hudson. Once inside the house, he passed a bundle wrapped in white paper to one of the Janes. She opened it, indicated its illegal contents with her eyes to the police and, while Frank was being arrested, officers drove his Hudson away. Veasey, as it turned out, had apparently been a patrol driver for the Tacoma police years earlier.

All total, the police arrested nineteen people; among the men were tailors, laborers, miners, waiters, cooks, mechanics and shoe blacks. No

occupations were listed for any of the women, who ranged in age from twenty-one to thirty-four. Under the Beeler Narcotics Act, the penalty for being found guilty was ten years in the state penitentiary. A number of those arrested pleaded not guilty. Deputy prosecutor Leo Teats went on record as saying, "Some of these birds wouldn't plead guilty if we had them pinned to the mat."

A few days after the bust, the property owner appeared before the Board of County Commissioners saying that since the house had been used for immoral purposes and as a rendezvous for dope users, its rental value had been injured. C.M. Riddle and A.H. Harder represented J.C. Heitman of the Fidelity Rent & Collection Company, agents for the property in question. They all wanted compensation for the alleged damages. The board refused but said it would be guided by advice from the prosecutor's office. The prosecutor said that the house had never been used for immoral purposes because police officers had been in it with the young women at all times, also that the city had paid rent for the site. Attorney Riddle said the rent money had been obtained from the city through fraud.

The attorneys also asked that the two young women, the Janes, be ousted. Teats said, "The house will be kept intact with the young women in it until after the trials of the alleged violators of the Beeler Anti-narcotics law so that it may be shown to jurors. All resources of the police department are available to prevent the removal of the girls or the injuring of the house by force and that the prosecutor's office will fight any attempt to oust by court action."

In any event, the house was demolished about 1968, during the local push for urban renewal. The site is now open space/extra property for the Reverie at Marcato Condominiums at 1501 Tacoma Avenue South.

While the House of 100 Eyes enjoyed (or not) its fifteen minutes of fame, it competed with Tacoma's biggest bust; in April 1931, the *Tacoma Daily Ledger* reported that Prohibition agents had unveiled a still that could brew a gallon of moonshine a minute.

At the time, Pierce County's acknowledged kingpin bootlegger was said to be Vito Luppino (not to be confused with Tacoma's 1940s gangster Vito Cuttone), arrested on April 5, 1929, and interviewed by special treasury agent C.A. Murphy in July 1931. Luppino admitted paying one police officer $120 but otherwise kept his illegal activities close to the vest.

Tacoma's worst female offender was Theresa Torchini. She was arrested thirty times, had twelve police convictions and two run-ins with federal agents and got out of her last charge only because Prohibition was repealed.

However, the most ironic arrest had to have been when a gentleman named Dickman was sentenced to six months at a federal road camp and fined $300 because his wife, Margaret, had been picked up for selling a gallon of whiskey to a federal agent. At that time the law said that "if a married woman commits an offense in the actual or constructive presence of her husband, it is presumed that she was forced to." Mr. Dickman knew what his wife was going to do, so Margaret's attorney was able to get her off.

A revolt against Prohibition began in 1930. By November 1931, Tacoma's sheriff, Fremont Campbell, citing lack of room and inadequate resources, refused to accept prisoners arrested by federal agents. It was becoming obvious that the experiment in banning something people wanted had failed. Nor did it go unnoticed that repealing the Eighteenth Amendment and making liquor legal would create a manufacturing and distribution workforce that would provide a new tax base—always a happy event for government.

The irony, though, was that not everyone was happy. The newly created jobs weren't as lucrative as the illegal ones had been.

How Much Would You Be Willing to Pay?

Midwife Sells Baby for $25; Is Arrested
Mrs. Marie Brewer of Newport, Washington wanted a baby and came to
Spokane to buy a girl. She went to Dr. Emily Siegel, a midwife, who secured a
2-month-old baby from a girl in the Salvation Army rescue home. She alleged she
paid the midwife $25 for the little one.
–Tacoma Times, *October 18, 1913*

In 1926, Dr. George A. Lundberg, PhD, Department of Sociology at the University of Washington, made a survey of Tacoma's health, delinquency, dependency and club work and wrote a booklet, *Child Life in Tacoma: A Child Welfare Survey*. In it, he discussed the White Shield Home (for unwed mothers). It was, he wrote, a ten-year-old, white brick, two-and-a-half-story building with basement on twenty-two acres of elevated land—elevated for privacy—at 5210 South State Street.

As described in the survey, the home was "for unmarried girls needing maternity care for the first time, though any unmarried girl under the age of 21 years, anticipating a first confinement may be admitted upon her

France Is Buying Babies
The value of the baby rises as the rise of the family increases: $100 for the first two in a family, $200 for the third, $400 for the fourth is paid to the mother from the treasury of the republic when the baby is one year old.

—*Tacoma Times*, July 21, 1916

personal application, provided her health record is good…or for the protection of the community who are suffering from the first stage of gonococcus infection."

The home, the doctor wrote, had adequate light and ventilation, with steam heat, electric lights and plenty of bathing and toilet facilities. The building was in good repair, each resident had her own bedroom and there were accommodations for twenty-five girls and ten babies. Girls were expected to remain at the home for no less than one month after giving birth.

The home was operated under the State Board of the WCTU. It was a Christian facility with "no attempt to unduly influence the girls in the matter of the disposition of their babies." However, girls were "assisted in relinquishing their offspring," keeping in mind the religion of the birth mother. Dr. A.G. Nace was the regular medical attendant, working on a reduced fee basis. A matron, registered nurse and janitor composed the rest of the staff. The residents did all the routine work.

Oddly, all of the information in the report was provided to Dr. Lundberg by the resident nurse and matron. He apparently didn't actually visit the home.

As early as 1915, Tacoma nurses started an open fight to close all private maternity homes in Tacoma, with a special mention of the White Shield Home then located at 4214 North Huson Street. Mrs. Agnes R. Fletcher headed an organization "comprising every trained nurse in the city and county, and was head of the medical corps of Mountain View [tuberculosis] Sanatorium." "We are," she said, "in a position to see, probably better than anyone else, the evils of secret maternity."

Mrs. Fletcher went on to say that the home had originally been a school of correction for wayward girls but had become a secret maternity home where young girls went to hide their shame but also came into contact with girls of the other type. She advocated a county maternity home for unwed mothers, an opinion endorsed by Miss Donaldena MacDonald, a district nurse for the City of Tacoma. As a result of the nurse's intention to "wage war on private maternity homes handling secretly the cases of unwed girls," they insulted

CHILDREN'S HOMES.

WHITE SHIELD HOME. 4212 Huson st. Take Pac. av. car at wharf or depot, transfer at Ninth st., walk two blocks up to Point Defiance car, ride to Huson st., then walk two blocks to the left.

CHILDREN'S HOME—Parents or guardians desiring to place children in the home may apply to Mrs. G. W. Bullard, 523 North J st., between the hours of 12 and 1 o'clock.

TWO or three children to board; private family. I keep a cow. 3321 Sixth ave-

Some of the children's homes charged with baby trafficking. *From* Tacoma Times; *author's collection.*

the state membership of the WCTU. Dr. Eve St. Clair Osburn, president of the White Shield's Board of Managers immediately shot back: "I'd just like to see the nurses of Tacoma or anybody else try to put the White Shield Home out of business," she said. To her, the nurse's statement that the girls would have a better opportunity to reform and a "better environment for pure thought in a municipal maternity home, supervised by trained nurses than they would in a private institution," was a red flag waved at a bull.

She went on to say that Tacoma's bad girls were sent to the Tacoma Vocational Home at the west side of town. The White Shield Home took care of innocent girls who had been wronged. They were usually between ages thirteen and eighteen and came from Tacoma High School and the University of Puget Sound, and a great many were from Seattle, just as Tacoma girls sometimes went there. Instead of a regulation hospital, she wanted the residents to feel as if they were in a private home. When a physician was needed, Dr. Ella E. Fifield or another female physician was on call. But one of Dr. Osburn's statements may have come back to haunt her: "Some of the girls take their nameless babies away with them and raise them. Others turn the babies over to the Children's Home Finding Society."

Therein lay the problem. In June 1936, the *Tacoma Times* broke the story of a baby-selling racket in Tacoma.

Two months earlier, Walter E. West, manager of the Tacoma Better Business Bureau, began investigating what he called "a baby-buying racket." He said about a dozen places existed in town from which people could buy babies. For those interested, it was only necessary to read some of the subtle advertisements in the classifieds, notices such as: "Private confinement home; strictly confidential"; "Want to adopt a baby, either sex, of healthy parents; pay expenses"; "Private maternity home; eminent physician, graduate nurse; confidential; arrangements to suit parents." He claimed that these ads and others like them had helped keep the business going, and Tacoma papers agreed to stop all such classifieds.

Naturally, those who ran the homes protested. "We merely provide a place where these poor, unfortunate girls may come, and we help place the baby afterwards. Of course there are charges for the doctor, nurse, and board, and the person who adopts the baby pays these." West claimed they were paying up to seventy-five dollars. Also, adopting couples paid a five-dollar adoption-filing fee and attorney's fees for handling the case in court. One woman told him that in sixteen years, 236 babies had been born at her home and in only one case did the father pay the costs. In all the other instances, payments were paid by the adopting parents.

"Bartering in human flesh," West said. "I'm convinced there is a ring operating in the business on the coast."

West wasn't as ruthless as he sounded. One home run by a woman and her young daughter that he visited had no fuel, food or money to buy either. "How can a young mother and her baby get proper care in a case like this?" he asked.

As so he began advocating for state inspections; he also warned prospective parents that they had no guarantee the child they adopted would be mentally healthy and/or not of mixed race.

Not long after the *Tacoma Times* articles, representatives of various societies and public departments were scheduled to meet and draft a proposed

A baby was sent to the New Haven poor house not long ago under singular circumstances. Both parents had eloped, the father with another man's wife, and the mother with another woman's husband.

—*Weekly Ledger*, December 9, 1881

WHEN WILL MEN LEARN LOVE LOYALTY?

Only When Woman Demands It, Says Miss Grey, As She Publishes An Extraordinary Love Confession From a Business Man — A MESSAGE AND A WARNING TO GIRLS WHO WORK.

"When Will Men Learn Love Loyalty?" Article warning girls about affairs with married men. *From* Tacoma Times, *April 3, 1915.*

city ordinance. The ordinance was to "serve as a model for a bill to be introduced at the next session of the legislature so that regulation would be uniform throughout the state."

The White Shield Home operated until 1956, when it closed, and the building became the Laurelhurst Nursing and Convalescent Home. Five years later, it became the Faith Home for unwed mothers. Currently it is the Har Mel Care Facility.

WHEN STOMACHS ROSE AND FELL WITH THE TIDE: SALMON—EGGS?

Salmon fishing in Puget Sound never had the cache of salmon fishing in Alaska. That's not to say people didn't toss out a baited hook and hand line and catch their dinner, but news stories about salmon generally cover the fish and canneries up north, even Alaskan salmon eggs. That's where the Chemical Products Company at 2709½ North Proctor, slightly north of where Knapp's Restaurant, came in. Chemical Products made Dok's Trout Charm.

Salmon eggs chosen for their size and color were shipped down in large barrels and immediately upon receipt went through a preserving process that helped them keep their color, oils and albumin (proteins of the albumin family are only moderately soluble in concentrated salt solutions) and remain soft and not stick together.

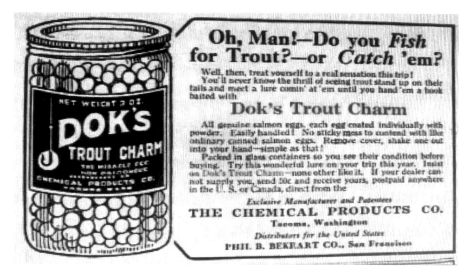

Advertisement for Dok's Trout Charm. *Author's collection.*

At the plant, men preserved them in a special process, dried them and coated them with a white powder that kept the eggs from sticking in the jar but washed off when the egg hit water. The eggs then went into jars using a special vacuum-packing machine that sucked the air out. The last step was to dip the jars in paraffin. Eggs shipped back east were a revelation to East Coast fishermen who had never used prepared salmon eggs to trout fish.

The Proctor Street facility was putting out more than six hundred gross of canned eggs in 1921, but it took B.J. "Dok" Sliter, a druggist for the Stone-Fisher Company, a number of years to come up with the process that he patented.

Dok was born in the Grand Rapids, Michigan area in 1873 and lived in Tacoma from 1918 to 1923. He and his partner, Ray Gamble, applied for a patent on the Trout Charm in 1920. Apparently their plans fell apart. In early 1921, the company reorganized with Harry Fisher, vice president of the Stone-Fisher Company, as president; Dok Sliter as vice president; Clifford Sliter as secretary; and Bert Smyser, designer of the Java Jive, as treasurer. The company then advertised in *Field and Stream*—"If your dealer cannot supply you, send 50¢ and receive yours," and the *American Angler*—"The Genuine Miracle." It was anticipating canning more than five thousand gross in 1922 and had outgrown the Proctor Street facility. However, for unknown reasons, their plans apparently fell apart; the company was so short lived it never made it into the city directory.

> ### America Most Picturesque Harvest
> Reaping Crops of Leaping Salmon on the Columbia
> YES, HORSES AND LAUNCH GO SALMON FISHING ON THE
> LOWER COLUMBIA.
> …the net was alive with fish, leaping and writhing,
> and twisting straining against the sides, blindly looking
> for a way of escape, but there is none.
>
> —*Tacoma Times*, August 16, 1909

Egbert J. Sliter left Tacoma about 1923 and died in Fresno, California, four years later. Ray Gamble built the Gamble Building on the Chemical Products site in 1929. The University of California researched the prepared fish eggs patent in 1974, but it is unknown if anything came of this.

TRAINS AND "TATERS"

On July 14, 1873, all of Puget Sound waited for the announcement to see which settlement the Northern Pacific Railroad would choose as its terminus. Tacoma beat out Seattle, and Seattle carries a grudge to this day. The first steam train reached Tacoma on December 16, 1873, and the "the line was accepted for regular operation in May of 1874." However, it wasn't long before other railroads such as the Union Pacific and Great Northern Pacific began looking to expand to Tacoma, and the Great Northern, in particular, offered strong competition because of its dining car favorites: chicken pie and gingerbread crumb pudding with butterscotch sauce.

George Pullman had introduced the first all-dining car in 1868, and many other railroads were quick to follow suit: the Northern Pacific in 1887, Union Pacific in 1890 and Santa Fe in 1891, but it was the Great Northern that worried NP superintendent Hazen Titus.

Titus became the NP's superintendent in 1908, and one of the first things he did was ride its route. While in the Yakima Valley, he heard two farmers discussing the unusual problem they were having with their potato crops. They were harvesting foot-long, five-pound spuds that were too big to sell. Homemakers, they said, had decided that any potatoes

bigger than nine or ten ounces were just too big to be effectively fried or baked and so were being used as pig feed. The story intrigued Titus, and when the farmers disembarked, he did, too. He bought a box of giant potatoes and took them to the railroad's commissary in Seattle. Over the next few days, Titus experimented until he came up with a perfect baking potato—one about two pounds and with no obvious marks or mars. Baked two hours and rolled on a hard surface to separate skin from meat, split open and topped with a dollop of butter, it was, he decided, the perfect signature dish for the Northern Pacific. Titus posted notices at Columbia Basin stations offering top dollar for all unblemished, two-pound tubers Yakima Valley farmers could produce. Chefs on the NP's premier train, the *North Coast Limited*, introduced the giant baked potatoes, called Netted Gem Bakers, to passengers on February 9, 1909. To advertise his gems, oversized replicas of potatoes were mounted on commissary and station buildings along routes. Netted Gems cost ten cents, and their popularity caught on so fast, yearly consumption by railroad passengers regularly topped off at 265 tons.

In keeping with the practice of other railroad lines, the NP offered other regional specialties: chowder made from Puget Sound clams, beer made with Washington-grown hops and pies from locally grown apples. The railroad operated a fifty-two-acre dairy and hog and poultry farm

N.P.'s Big Baked Potato Makes Hit at N.Y. Dinner

Hazen J. Titus, N.P. dining car magnate, and his big baked potato, carried off the honors at the fourth annual banquet of the Far Western Travelers' Association at Hotel Astor last evening. An immense illuminated floral piece of the N.P's famous spud greeted the eye of the diners. It was the first time it ever had been done in flowers. During the dinner potatoes weighing four pounds and more were served [to] every individual. Mr. Titus brought on a staff of his own cooks to see that they were prepared in the usual N.P. manner. Individual fruit cakes baked in the form of suitcases and bearing the insignia of the association were distributed to the guests. An immense 40-foot illuminated Baked Potato, spurting steam from its creamy, mealy split top made the rounds of New York streets.

—*Tacoma Times*, February 6, 1917

in Kent; containers for eggs, milk and cream were all stamped with freshness dates; butter was churned on board daily. Branching out, NP chefs used North Dakota–grown wheat for bread, Montana buffalo and beef, prunes from Oregon and trout caught in various waters of the Rocky Mountains. It only served Minnesota spring water. Then, feeling it needed another specialty, the railroad hired an award-winning European chef who set about making his prized fruitcake.

Sophisticated meals in elegant dining cars at tablecloth-covered tables set with good-quality crockery, glassware and flatware soon became an expected part of railroad travel, with each line eager to offer the most luxurious food: the New York Central, scaloppini of pork tenderloin with Riesling wine; the Texas and Pacific, cantaloupe pie with meringue; the Baltimore and Ohio, Maryland crab cakes and oyster pie; the Southern Pacific, baked, sugar-cured ham. But the Northern Pacific had one thing that the other railroad lines didn't. In 1915, to the tune of an A. Seymour Brown song, Mrs. A.F. Wolfschlager wrote the lyrics to a song she called "The Great Big Baked Potato."

Sometime after dinner at the Astor, Titus traveled to Washington, D.C., and met with Herbert Hoover, head of the department of U.S. Food Administration. Because of the war, Americans were asked to donate horses, weapons and ammunition and ration their food so the soldiers could eat. Titus decided to cut the portions served in NP dining cars by half. The *Tacoma Times* called it a "unique innovation" when Titus also cut prices. "We are now serving the same number of patrons with half the amount of food formerly required," he said. "The difference represents a vast food savings to the nation." He reviewed portions the NP served right down to tea leaves.

In the United States, tea bags date either to 1901 and were invented by Wisconsin women Roberta C. Lawson and Mary Molaren and patented as tea leaf holders, or in 1908 by a tea merchant named Thomas Sullivan. Regardless of who came up with the idea, Titus had tea bags made so the amounts they contained—one teaspoon each—would be uniform. He also suggested housewives measure and/or weigh their food, saying they paid "little attention to the details."

The golden age of railroad fine dining ended during World War II, but the recipes remain in James D. Porterfield's book *Dining By Rail: The History and Recipes of America's Golden Age of Railroad Cuisine.*

CAMOUFLAGE, CAMOUFLAGE ARTIST AND A LITTLE ABOUT CEREAL

For some one hundred years, the 1909 Wright Military Flyer, the world's first military airplane, has been on display in the Smithsonian National Air and Space Museum. The two-seater observation aircraft never actually saw duty. It was used for flight training.

It was built because in 1908, the U.S. Army Signal Corps requested bids for a two-seat observation aircraft. That September, Orville Wright took a Wright brothers plane to Fort Myer, Virginia, and the army's official observer, Lieutenant Thomas E. Selfridge, joined him on a demonstration flight. Partway through the trials, the plane malfunctioned and crashed. Wright was badly injured, and Selfridge was killed. The following year, both Wilbur and Orville had a new airplane ready for trials at Fort Myer. This time they were successful, and the signal corps accepted the Wright brothers' airplane; the military's aerospace industry was underway—just in time for World War I.

Wartime aerial reconnaissance helped armies locate the enemies' positions. That meant soldiers on the ground needed ways to "hide from, observe, and deceive enemy forces." Enter the French, who, in 1915, developed camouflage to help keep equipment and positions hidden in plain sight. Various branches of the military began recruiting artists as camouflage artists, and Tacoma's Enid Jackson applied for acceptance to service overseas in the aviation camouflage department.

Miss Jackson was born in 1896 to Canadian physician Dr. Robert G. Jackson and his wife, Robina Ann. The family had money. Dr. Jackson moved to Tacoma from Victoria, British Columbia, sometime around 1912 seeking medical care. His hobby was history, particularly accounts of the legions of ancient Rome. Somewhere he read that the Roman foot soldiers' daily rations consisted of two pounds of wheat or rye and that the grains gave them "the strength and stamina to conquer the world." So he followed their example, added to it and created a hot breakfast cereal called Dr. Jackson's Roman Health Meal. It had whole-grain wheat, rye, bran and flaxseed, which he felt corrected deficiencies in vitamins and minerals. In fact, he believed so strongly in the product that he prescribed it to some of his own patients. When the cereal caught on, Dr. Jackson built a small factory in Tacoma to keep up with demand

Back to Miss Jackson: she graduated in 1915 from Annie Wright Seminary and went on to attend the Ogontz School for Young Ladies, near

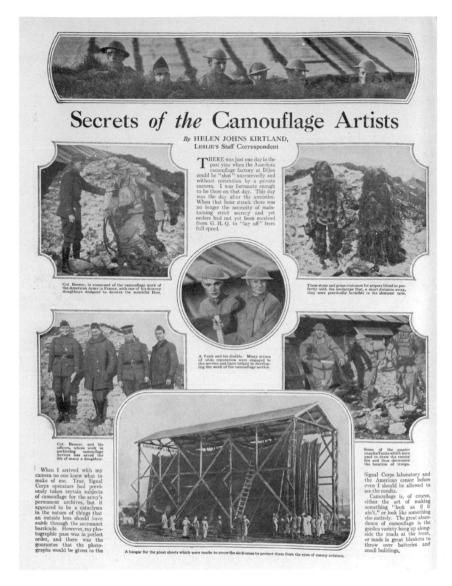

"Secrets of the Camouflage Artists." *Courtesy Library of Congress.*

Philadelphia. As a girl in Tacoma, around age twelve, she learned to drive. While at Ogontz, and unknown to her parents, Miss Jackson took an aviation class in order, as the papers said, "to learn from the sky how to correct colors for purposes of deception." Also, according to the newspaper, she flew as well as she drove.

Camouflage artists worked in a number of different fields. Initially, the military's most commonly camouflaged items were guns and vehicles. People soon realized battlefield mud did just about as well.

"Dazzle" was the name for the distinctive patterns painted on ships. The designs consisted of bold shapes and lines in conjunction with contrasting colors to help distort a ship's physical form. "This made it difficult for submarine commanders to assess a ship's size, shape, course, and range." Camouflage trees were something else the artists provided. They went to the battlefields, drew sketches of specific trees and made replicas of them. Men then went out at night, cut the real tree down and replaced it with the fake one. They were hollow and provided dangerous observation posts for men inside. However, the process involved in drawing, cutting down and replacing were all highly dangerous tasks, too.

And finally, camouflage artists made papier mâché heads to draw out snipers and reveal their positions.

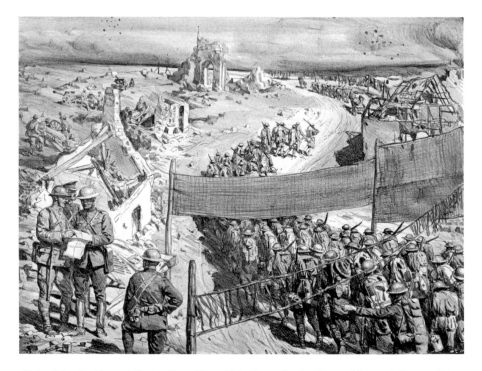

"Marching in Along a Camouflaged Road," by Jonas Lucien Jonas. *Library of Congress Prints and Photographs Division 20540 USA [LC-DIG-pga-03883]; original copyright by Wendell Westover.*

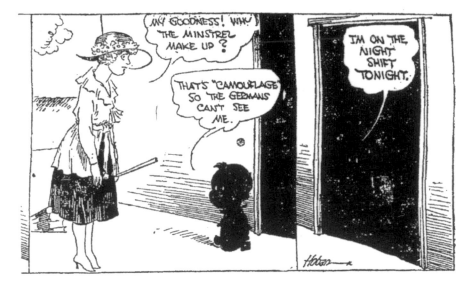

Newspaper cartoon titled "Jerry on the Job," dated September 17, 1917, by Walter Hoban, himself a World War I sergeant in the military police. *Author's collection.*

At school and while flying, Enid Jackson paid particular attention on how to disguise roofs. She sent an application to the aviation camouflage department, which wired acceptance of her application in June 1918. Dr. and Mrs. Jackson were back east at the time; Dr. Robert Jackson had just given his daughter a new Mercer sport-about as a graduation gift, and the family decided to drive to Virginia to visit relatives before heading to Minneapolis, where they would leave the car and continue to Tacoma by rail. Enid Jackson was scheduled to leave Tacoma in August 1918.

Since World War I ended in November 1918, Enid's work would have been brief, but she didn't completely disappear from history. She married a Kansas City banker named Rufus Crosby Kemper and had two children: Sarah Ann, born 1923, and Rufus Crosby, born 1927. The Kemper family was very wealthy. Under Rufus Kemper's leadership, City National Bank (now United Missouri Bank) grew from a three-man operation with $600,000 in deposits in 1919 to a seven-hundred-employee institution with $300 million in deposits when he stepped down as chairman of the board in September 1967. Crosby also served as a regent at Rock Hurst College, president of Interstate Securities and director of Kansas City Title & Trust Company. And knowing how wealthy the family was, in 1933, a thirty-four-year-old unemployed man named K.W. Lattin broke into the family home.

He ordered one maid to telephone Mr. Kemper and tell him Sarah was ill. Another maid heard the conversation and locked Sarah and herself in an upstairs room, from which she telephoned the police. Enid Kemper had been away, and when she returned home, the man pointed a gun at her and demanded $15,000 or he would kill Sarah. The police came; Lattin tried to commit suicide but failed and was taken to the hospital.

After that excitement, the Kempers kept a low profile except when they were endowing buildings. In 1973, Enid and her husband formed the Enid and Crosby Kemper Foundation and gave $2.25 million to Annie Wright Seminary for its 100th anniversary.

Enid Jackson Kemper died in 1979, seven years after her husband.

In 1927, her father sold his Roman Meal (cereal) Company to William Matthaei, who combined his bread-making skill with Dr. Jackson's formula. Matthaei kept the headquarters in Tacoma and developed Roman Meal Bread.

SMILEAGE BOOKS, PNEUMONIA JACKETS AND TUBE SOCKS

When the United States entered World War I, non-military personnel were very much a part of the war effort. If there was a shortage that civilians could help alleviate, officials at Camp Lewis asked various local organizations, such as women's clubs or the Red Cross, for help. Most ladies belonged to a club, and working together, they raised enough money to buy a garment-cutting machine. Tacoma businessman Sam Perkins, owner of the Perkins Building at the southeast corner of Eleventh and A Streets then loaned them space for a workroom on the building's first floor.

At home, during school recesses and at church or the theater, women and children knit. One boy at Docton Elementary knit a sweater every two weeks, while other students turned out twelve in a month. Older students who knew how to turn a heel knit socks; others knit the tube to where the heel would be turned and then passed the sock on to someone else to finish. When some Red Cross chapters acquired knitting machines, these miracle workers could turn out a knitted tube in approximately forty minutes. And as it turned out, men preferred tube socks to socks with a poorly turned heel.

In addition to socks, people knit hats known as balaclavas, which had flaps over the ears that could be lifted so soldiers could listen for the enemy;

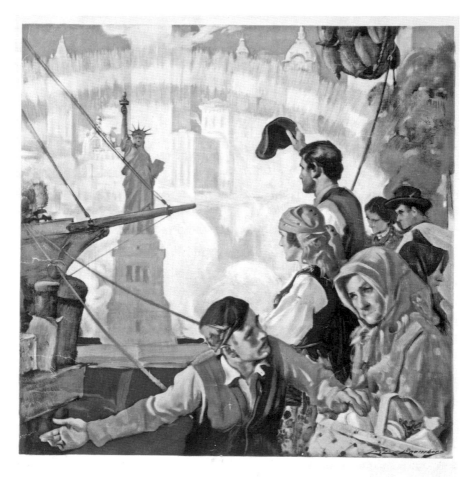

A government "Waste Nothing" poster. *Library of Congress, Prints & Photographs Division, WWI Posters [reproduction number, e.g., [LC-USZC4-9880].*

"Our Boys Need Sox." *Library of Congress, Prints & Photographs Division, WWI Posters [reproduction number, e.g., [LC-USZC4-9863].*

gloves that had a separate forefinger and thumb to make firing a gun easier; and large knitted belts to keep the internal organs warm in the trenches. However, in March 1918, a Camp Lewis commander required that all men deployed to the front wear two pair of socks at a time. Neither the trench boot, which lacked waterproofing, nor the improved Pershing boot, which didn't, held up well, and wet feet often meant foot fungus, trench foot or loss of feet. So it was socks, socks and more socks.

Pneumonia jackets were an item of clothing usually made out of oiled silk or muslin and, "sometimes, even included a system of rubber tubing that circulated hot water around the chest as a means of keeping the patient warm." A nurse at the time rather sarcastically said the jacket was a garment designed to keep the patient warm, particularly if it was used in conjunction with a mustard plaster, while he was being treated with quinine to cool him down. Nevertheless, people set great store by them.

There were other needs, too. In addition to socks, one order from Camp Lewis to the local Red Cross asked for the following: 6,000 operating masks, 2,000 operating caps, 1,380 bed shirts, 1,350 taped bed shirts, 800 pairs of pajamas, 550 each bed sacks and bandaged foot socks, 440 operating jackets, 375 bed jackets, 210 convalescent gowns and 2,470 surgical pads. When the United States couldn't provide all the cotton needed, people went into the woods and gathered sphagnum moss to fill the surgical pads.

While men, women and children knit and sewed, other things were going on. Tacoma barbers demanded that one hundred homes and rooms near South Tacoma be set aside to create the world's largest barbershop. Soldiers became interested in boxing because it was thought to increase efficiency in bayonet usage. Camp Lewis soldiers also began jiu jitsu training with emphasis on bone snapping and muscle tearing.

And then there were Smileage books. Smileage books were books of twenty coupons that admitted soldiers in training camps to plays brought to

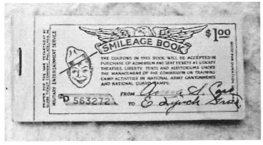

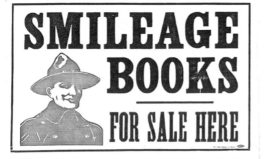

Above: Old magazine illustration of a pneumonia jacket. *Origin unknown.*

Left: An ad for Smileage books and one of the coupon books. *Author's collection.*

the camps by the Commission on Training Camp Activities. Ralph Shaffer, the personal representative of the military's Entertainment Council for the Northwest District, introduced the books on January 9, 1918, and they made their appearance at Camp Lewis on the twenty-ninth. The War Department issued the books, and the tickets were labeled "Good for the duration of the war." The books cost one dollar, and individuals were encouraged to buy and send them to their relatives. In a letter to his brother, a soldier named Ned wrote, "The government started out with the idea of making the shows free to the soldiers, but the fellows didn't like it. You know how it is, Ted, if a show is free, it makes you think of home talent. But where at home you pay two dollars, we get the best seats in the house for fifty cents…and movies are only a dime…There are ten trips to the movies in a Smileage book. If a fellow has a ticket for the theater, it gives him something to think about all day. So send some more Smileage Books, Ted, and pass the good word along. You can buy them now at banks, five-and-ten-cent stores, and plenty of other places."

Ned's letter was made public along with a photograph of actor Douglas Fairbanks donating $100 "for Smileage."

A READER BOARD AND A MEGAPHONE AT LEDGER SQUARE

Before there was big-screen TV, cable, pay-per-view—before there was television, before there was the Tacoma Dome and retractable-roof stadiums, Tacoma had a player board and a man with a microphone.

Shortly after World War I, the Tacoma Daily Ledger building moved from Eleventh and A Streets to Seventh Street and St. Helens Avenue. In addition to printing a paper, the Ledger co-owned a radio station—KGB—with the William A. Mullins Electric Co. The station was started by an amateur radio enthusiast named Alvin Stenso who was well known in Tacoma. On August 18, 1918, Stenso was in the navy when his ship was torpedoed. He had been reading a book when the blast threw him out of his chair. Before sending out distress signals, he took time to write his name and date in the book he'd been reading—VanDyke's *Humoresque*—and the information that he'd been torpedoed. Amazingly, the book was later salvaged and ended up in the hands of a woman living on the East Coast, who returned it to him.

But back to Tacoma: when Stenso married Miss Bjorhild Silvertson on July 29, 1922, in a Lutheran service officiated by Reverend Ernest Bloomquist, the wedding was broadcast live, a first for radio. The ceremony started at 7:00 p.m. with the wedding march. Guests gathered at the Stenso home to listen on crystal sets, and a crowd formed in front of the radio station to hear the broadcast. It was so large that police were called in to keep the sidewalks clear. That's about the time that particular area of St Helens Avenue in front of the Tacoma Daily Ledger building was dubbed Ledger Square. However, the station was only in operation in Tacoma until December 11, 1925—until not long after the *Ledger*'s owner died. The Stenso marriage didn't last either.

When the regular broadcasts began, they started with an assortment of announcements, and the Hopper-Kelly Music Company provided snappy dance tunes—the latest foxtrots and waltzes.

The first sporting events broadcast at Ledger Square were championship fights. The paper estimated a gathering of five thousand when Jack Dempsey fought Argentine Luis Firpo in September 1923. At that time, a local announcer received Associated Press bulletins directly from ringside and read them into a loudspeaker. Every punch and jab was noted. Policemen controlled the crowd, which filled both St. Helens and Market Streets. Dempsey won by a knockout, and the people went wild. Hundreds of men hung around the Ledger building to buy the first editions.

The famous 1926 Gene Tunney–Jack Dempsey match was also broadcast from Ledger Square. A local named "Caruso" Watson had been hired to "bellow the round by round action to the waiting crowd." When he was a no-show, Mr. Louis K. Woodford, of whom we know nothing more than he was a member of B Company, Tacoma's Home Guard during World War I, pitched in. Using a megaphone, his voice could be heard above the noise of the crowd, the streetcars and automobiles.

Championship fights consistently drew large crowds, and at a rematch in 1927, the Dempsey-Tunney fight drew record numbers. Across the street from the Ledger building was the fifty-two-unit Hyson Apartment building (702–14 St. Helens and since torn down). This time, Johnny Pepe was handling the mic. Pepe was a boxing aficionado; he and a man named George Shanklin were original promoters of the Greenwich Coliseum at South Thirteenth and Market Streets. That was where Tacoma went to dance to big bands, attend political rallies or see the pugilists perform. He and Walter Hagerdorn also opened the Kay Street Athletic Association at the Glide Skating Rink on South L Street, which hosted boxing matches for years to come.

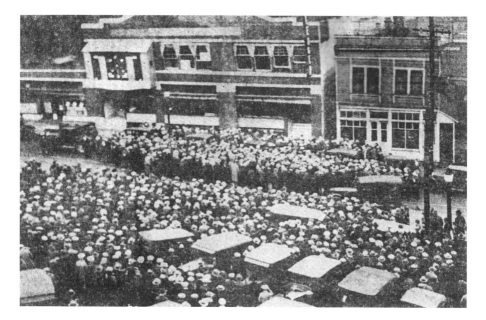

A photograph of Ledger Square, 1920s. *Author's collection.*

After the fight, the newspaper made the following claims: Pepe's voice probably carried clear to Sixth Avenue, the strength of Pepe's voice stopped the streetcar, people waiting for the streetcar must have been entertained and Hyson Apartment dwellers had to keep their windows open to avoid the power of Pepe's voice from breaking the glass.

One of the first things the newspaper did at its new headquarters was to erect a giant sports events player board on the side of the building facing St. Helens. Measuring approximately five by seven feet, the player board offered sporting fans who gathered in front of it a way to experience high-profile events in a way that hadn't been possible before. The board had a baseball diamond layout, with places on either side for the names of the competitive teams and their inning-by-inning statistics.

The 1926 World Series saw the Cardinals defeat the Yankees four games to three. In spite of rain showers, both Market Street and St. Helens were jammed with people. The *Tacoma News Tribune* called the crowd the largest "that ever saw a World Series game in Tacoma." The games were broadcast, play by play, from the Associated Press's direct wire service into a Magnavox loudspeaker. Though generator noise impeded the sound during the first game, the problem was quickly solved so that subsequent games could be heard loud and clear. A *Tribune* ballplayer

crew worked the board and reenacted the moves for every pitch, strike and hit.

Ledger Square also acted as a reception area for visiting sports dignitaries. Babe Ruth and Bob Meusel were there on October 19, 1924. The paper called them Bustin' Bob and the Big Boy or Big Bam. The two threw out autographed baseballs to the men and boys, which caused mini riots. They were taken on a tour of the town, went to the Veterans' Hospital to visit the patients and showed up somewhere in headphones, posing as telephone operators. Ruth also played an exhibition game at Stadium Bowl.

Tacoma native Ted Wakefield remembers that just before enlisting in the navy during World War II, he used to leave the YMCA at 714 Market Street and stop at the square to watch the action. However, by the late 1940s, television was on the way. In February 1949, the *Tacoma Times* had an article titled "What Is Television." It was the third in a series of articles and included a picture of members of the Tacoma chapter of the League of Western Writers who had gathered at the Women's Clubhouse to hear a lecture and watch a demonstration on television. Weisfield and Goldberg's radio department provided an RCA combination radio, phonograph and television for the demonstration. A reader board and a megaphone at Ledger Square were no longer necessary.

STALEMATE: THE DEPRESSION YEARS

*Today much of the transactions upon the New York Stock Exchange is in the
nature of gambling and consequently the actual business of the country will be
no more affected by the present deflation than if one man lost a million dollars to
another in a poker game.*
–Tacoma Daily Ledger, *October 30, 1929*

SHIPS NO ONE WANTED: THE FOUNDATION COMPANY

On August 25, 1917, the Foundation Company, one of the biggest
construction companies in the United States, announced plans to build a
third shipyard in the Pacific Northwest.

As its name suggests, Foundation was a company specializing in putting
foundations under existing buildings in New York City. It was headed by
Franklin Remington, of the same Remington family who made firearms.
He also started the Remington typewriter business and, when World War I
began, branched out into shipbuilding. He began making wooden, masted
auxiliary schooners for the French government, many of which were used
for shipping food.

The company already had shipyards at Victoria, British Columbia, and
Portland, as well as up and down the East Coast, but with new contracts
from both the French and United States governments, another was needed.
Seattle and Tacoma were, as usual, in competition.

Tacoma won.

There was a stipulation, of course. The company spent nearly $5 million on a piece of Hylebos "water-swept waste of tidelands," located on fifty acres of tide flats, between Todd Shipyards and the continuation of Eleventh Street, bordered on the east by the Hylebos Creek and on the west by the Wapato Waterway. The city had to promise to extend the streetcar line out that far. Amazingly, everything was ready in less than three months.

The Tacoma facility employed 4,500 men. In 1918, it was believed to be the largest shipyard for building wooden ships in the world. The vessels built there were five-masted, wooden steam auxiliary schooners known as ferry schooners. The deadweight of each was three thousand tons. They were approximately 260.0 by 45.5 by 22.5 feet. Each one had small, triple-expansion steam engines and two smokestacks. Because of the fire danger, the yard had twenty-six fire plugs with hoses nearby, two chemical carts and several gangs of men whose job it was to sweep up wooden chips, shavings and other litter.

The first keel was laid on November 6, 1917. The first ship, the *Gerbeviller*, was launched on May 1, 1918. The ship *Reims* had a midnight launch on June 19, watched by a party that included Remington; Mr. Bayley Hipkins, the Foundation Company's Pacific Coast manager; George P. Thorndyke, shipping commissioner; Captain Reo, inspector general, French High Commission at Washington, D.C.; Captain Tristan, inspector of the hulls; Captain J.S. Bulong, pilot and master mariner; Captain Miunioni of the French navy; M. Le Guylloux, a French naval engineer and inspector of the French High Commission; Mr. Frank Walker, French government inspector of Bureau Veritas, Puget Sound division; Mr. R.H. Laverie, head of the Bureau Veritas for the United States; and F.W. Drury, an assistant manager of the Foundation Company for the Pacific coast. They were joined by cheering spectators and sounds of "The Star-Spangled Banner." Remington withheld comments until he returned to New York, at which time he said, "There is such a demand for wooden

The Bureau Veritas was founded in Antwerp, Belgium in 1828 as an information office for maritime insurance. It had a simple mission: to give shipping underwriters up-to-date information on premiums in use at commercial centers and provide precise information on the state of ships and equipment.

–Wikipedia

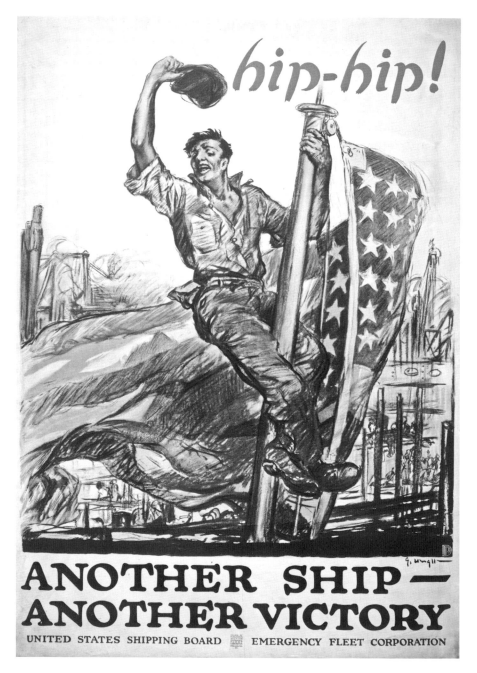

"Another Ship, Another Victory." *Library of Congress, Prints & Photographs Division, WWI Posters [reproduction number, e.g., [LC-USZC4-10784].*

vessels now, that there will be wooden vessels built for several years to come. The Northwest coast in this work is the logical place for a shipbuilding plant and that is why we located here and why we shall remain a big yard here."

Tacoma's branch of the Foundation Company had a resident nurse, and the men organized a mandolin and guitar club. They went fishing together and had company family picnics.

> Tacoma's northwestern sky was brilliant with a red glow from midnight to dawn as 13 war-time ships were burned to the water's edge in a great $1,500,000 bonfire.
>
> —*Tacoma News Tribune*

During construction, delays in receipts of machinery and a continual need for replacement parts were regular problems. Perhaps the problems, plus the speed with which the ships were being built—one a week—explain why, right from the start, they had a dismal record of engine and boiler failures, faulty navigation and leaks. The Foundation Company ships were among the least successful wartime wooden vessels built. The company might have had an order from the United States government, but every ship built at its Tacoma yard was designated as being for the French. When the war was over, a number remained at the shipyard because no one wanted them. Private bids of one dollar a vessel got rid of a couple, and Foss Tug bought one. Eventually, the rest were towed through the locks into Lake Washington and anchored in Lake Union, much to the disgust of residents there.

World War I ended on November 11, 1918. The Foundation Shipyard Company in Tacoma plodded along, completing its twenty-ship contract in November 1919. After the twentieth ship was built, a company spokesman went on record as saying that most definitely the Tacoma and the Portland facilities would stay in operation. They were both shut down shortly after the statement.

Within a few years, the ships left here became waterlogged, and there were concerns that they would break away from their moorages and drift into the shipping lanes. Also, so much time had passed that their timber was considered unsalvageable. The Washington Tug and Barge Company finally bought them for their iron. The company then had to figure out how best to salvage the iron.

Ultimately, a decision was made to tow the ships south to Minter Bay, where "a long sandpit, a long flat beach, and a tide range somewhat greater than in Tacoma or Seattle made this an ideal place for the job." There they were beached at high tide, fastened to anchors, tied together and set on fire. The plan, though, had a few faults: the boats burned, but so did the ropes

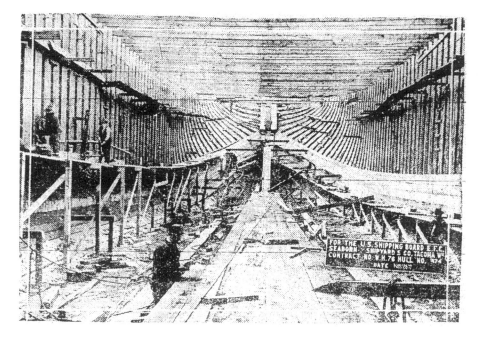

Inside a ship under construction. *From* Tacoma Times, *March 19, 1918.*

securing them; also, only parts above the waterline were destroyed. The hulls remained intact. As the wood burned, the iron parts dropped down in the water and settled on the sand below. They were picked up by scows on low tide. Unburned and unanchored, some hulls floated away and were reported drifting in the Narrows Strait and Commencement Bay.

Eventually, the government stepped in. The unburned wooden bottoms were so difficult to sink that they were beached in convenient places, fastened with cables and left to the vicissitudes of time and nature.

DEPRESSION HOMES: TACOMA'S HOOVERVILLE

From the time he left the White House in 1932, [President Herbert] *Hoover lived in the lap of luxury in the* [Waldorf-Astoria] *Towers. To the north, visible from his windows, could be found the makeshift cluster of huts derisively called "Hooverville's"* [sic]. *They crowded in on one another in Central Park, browning large areas of grass. Almost as isolated from active political circles as Richard Nixon became.*
—Ward Morehouse III, The Waldorf-Astoria: America's Gilded Dream

For approximately thirty years, from the mid-1920s until 1956, a shantytown flourished on Tacoma's tide flats. It was located on the east end of the Puyallup River, midway between Carsten's Packing Company, a gas plant and the city garbage dump (pre-landfill term) on a three-hundred-foot-wide strip of land that was the government's flood-control reserve. Tacoma police officers called it Hollywood on the Flats because, they said, during the many times they were called to the site, they were told stories fantastic enough to be movie scripts.

Like some of the boathouses, families built Hollywood homes out of driftwood, sheets of scrap metal, canvas and old boards. If possible, they were even painted. A few of the shanties had birdhouses, trellises and gardens, but most were hovels. Occasionally, a man fitted an old car body with a stove, and the car became his home. Some of the shacks extended out over a slough that ran parallel to the river and acted as an open sewer. People carried water from a community faucet near Lincoln Avenue. To keep warm, they scavenged driftwood and picked up coal off the railroad tracks.

In spite of their poverty, many of the people were not without pride. Some got together and hauled planks of wood from the dump on two-wheeled carts. They used the wood to build elevated sidewalks. Because of Puget Sound's wet winters, the sidewalks were built on trestles approximately three feet above the mud.

Tacoma's Hooverville was home to several hundred people who had lost their homes due to accidents, foreclosures, prolonged unemployment, drought (in the case of farmers) and, of course, the Depression. By 1932, it was estimated that millions of Americans were living off the grid in shantytowns. Some of the residents were denied WPA work; others lacked the mental capacity to function in the outside world. To add to their problems, many of the men were discriminated against. They eked out a living with temporary jobs, illegal activities and garbage gleaning.

In Tacoma, people gleaned garbage in the city dump, an early form of recycling. Men raked through piles of rotting produce, burning ashes and putrid debris with

BODY FOUND AT TACOMA
A body was found by police in a shanty town hut near the Puyallup River last night. Death was believed to have occurred six weeks ago. There were no clues to identify.

—Seattle Daily Times, June 10, 1944

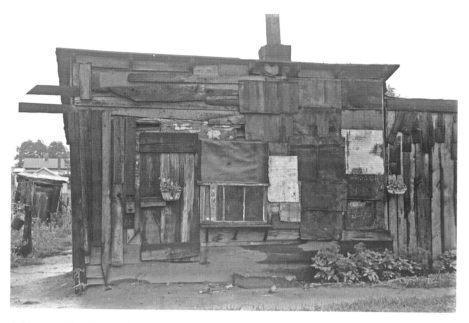

A Hooverville, "Home-Sweet-Home." *Library of Congress, Prints & Photographs Division, FSA-OWI Collection [LC-USF33-006579-M5].*

a specially adapted hook. The stench was nauseating. They collected glass, scrap iron and other metal, rubber and rags. A dozen or so two-wheeled carts and wheelbarrows waited near where they worked. At the end of the day, the gleaners loaded them with their findings. Everything was kept separate. When a junk dealer arrived at the end of the day in an old pickup truck, they dickered over prices. It was silent, grim, exhausting work for little return.

As might be expected, making and selling homebrew was an easier way to scare up some cash. At the tail-end of Prohibition, Nazer A. (John) Jounco, the King of the Flats, had a grocery store and still there. His recipe for hooch included ethyl alcohol, ethyl acetate, wood alcohol and gasoline. Jounco kept his brew in a fifty-five-gallon drum and sold it for twenty-five cents a pint. Buyers were supposed to add a pint of water and shake well. His business partners were his housekeeper, Melinda Hart, and a man named Charles Meade and his housekeeper, Irene Cameron. In April 1932, all four were arrested following the alcohol-related death of David Daniels, a Muckleshoot Indian. The arrests were the culmination of an investigation by the sheriff's department, the deputy prosecutor and an agent from the Bureau of Indian Affairs.

Hart, Meade and Cameron chose to serve time and pay fines; Jounce hung himself. The law enforcement men continued to investigate other suspicious deaths.

By 1937, it was estimated that Tacoma's Hooverville was home to fifty shack houses and 1,200 people; of the children, only 20 percent attended school. The area had the city's worst murder, suicide, juvenile delinquency and crime rates and health conditions. There were no nearby schools, playfields or churches. After Richfield Oil Company built storage tanks a third of a block away, residents lived with a constant threat of fire. But Hollywood on the Flats continued to grow. At the end of the decade, Tacoma's Hooverville covered a six-block area.

On May 20, 1942, Tacoma's fire department burned approximately fifty shacks under the direction of the coast guard. At that time, the average age of the residents was sixty, and on average, they had lived in the slum for eight years. The burning was supposed to be a safeguard for industries along the shores of the middle waterway. However, people just rebuilt.

The city council discussed eviction, but where were the people supposed to go? Tacoma's lack of low-income housing had become even more acute during World War II. Then-mayor Harry P. Cain stepped in, telling councilmembers that until the housing issue was resolved, Hollywood on the Flats and its subdivision, Sunset and Vine, would have to remain. A more important concern was how to keep military men away from the undeniable attractions.

After the war, eviction threats resurfaced. However, in July 1956, Hollywood's population was down to about sixty, and they wanted to stay. A former World War I cavalryman, Nick the barber, wondered where his friends would be able to affordably get their hair cut. Resident John Haj thought the neighborhood was "a real nice place for animals. Everybody," he said, "has a dog or cat and some keep chickens and there are several goats." Former logger Norwegian Carl Beckman said, "Here ve got room to valk, to scratch in the soil, sit out in da rocking chair on warm summer nights, to play with da cat." (The newspapers always wrote in dialect if one was used.)

Nevertheless, all of Hollywood's shacks were burned as a training operation for rookie firemen.

DEPRESSION CLOTHES: CHICKEN LINEN

Homemakers will have to do the best they can with what they have. Narrow or short sheets can be enlarged by adding pieces of old sheets, muslin, or flour sacks to one side and end.
—Alice Sundquist, extension specialist in clothing at Washington State College, October 29, 1942

From the 1880s to the 1950s, most people were familiar with the term "chicken linen." It referred to the material that household items such as flour, sugar and animal feed came in and that, once the bags were empty, was used to make clothing.

Prior to the appearance of cloth bags, food staples were packaged in wooden barrels, kegs, boxes or tins. However, the wooden containers wore out, and the tin ones rusted; neither was pest-proof and generally took a horse and team to carry. To make wheat easier to transport, women began weaving cloth bags and stamping them with family identification marks. A farmer could load a few bags on a horse's back or, if need be, carry one over his shoulder, making transport to the nearest mill and, once there, identification much easier.

In 1846, Elias Howe invented the sewing machine, which was quickly adapted for family use on heavy cloth. New England mills began weaving American-grown cotton, and textile bags gradually took over as the container of choice. The Civil War interrupted the otherwise smooth-running system, but it was back in full force by the 1880s.

As the cloth bag industry grew, the variety of items sold in them increased. Examples included bacon, sausage, ham, meat, salt, coffee, rice, peanuts, beans, soap flakes, bath crystals, starch, tobacco, fertilizer, mulch, cement and lead shot. And as more companies came along in the postwar years, each had its own logo or label stamped on its bags. A fad grew whereby women embroidered over the labels with the same color cotton thread and used the embroidered pieces of fabric to make quilt tops. However, when the popularity of textile packaging continued to grow, savvy manufacturers started providing instructions on removing the labels. They also began using non-permanent inks or eliminated the stamped labels and changed to removable paper labels.

Initially, since a barrel of flour weighed 196 pounds, a bag of flour was expected to weigh the same. Eventually, manufacturers sold flour in smaller amounts, representing one-half, one-quarter or one-eighth of a barrel in

How Can I Remove the Lettering from Flour and Sugar Sacks?

I Turn the sacks wrong side out and soak overnight in lukewarm water to which one tablespoon of kerosene has been added for each gallon of water. Wash with plenty of soap and rinse thoroughly.

2 Cover the inked places with lard and leave overnight. Wash out in warm soapsuds.

3 Soak the sacks in cool water for 20 minutes. Wring out and rub laundry soap well into the printing. Roll the sack up tightly and let stand for 20 minutes. Again rub soap into the printing, roll up, and let stand for 20 minutes. Wash.

–"The Homemakers' Question Box," September 30, 1942

weight. Other merchandise was sold in a variety of weights. Until 1943, there were no set measurements for any of the cloth bags, and they came in all shapes. A twelve-pound flour sack measured eleven by seventeen and a half inches, a bag to hold cotton measured nine by twelve feet and there were all sizes in between. Also in 1943, the War Production Board standardized bags into six sizes from two pounds to one hundred pounds. The wily shopper knew, too, that different manufacturers used different qualities of cloth. The Bemis Company, for example, made bags made from cambric, chambray, denim, percale and toweling.

Osnaburg was coarse cotton used to package farm items such as feed, seed and manure. Tacoma's Sperry Flour Mill shipped wheat destined for China in osnaburg sacks. Once the bags were empty, the cloth was made into the off-white jackets and pants associated with Chinese field labor. Wheat bound for Central and South America was packaged into bags of equally heavy cloth. The fabric had to be sturdy because it wasn't uncommon for men to unload the ships right on the beach and bags to be dragged to waiting teams of llamas. Later, the empty sacks provided material for ponchos.

During the Depression, the demand for cotton bags grew to where manufacturers, competing for homemakers' dollars, came up with a number of ways to make their packaging more desirable than that of their competitors and hopefully woo the shopper. Bags came with outlined patterns for stuffed toys or dress patterns printed on the inside. Some became aprons when the drawstring and one seam were removed, and hundreds were printed in patterns of flowers, dancers, boats, locomotives, bulls' heads and American Indians. In 1935, Sea Island sugar

The cover of instructions on sewing with bags. *Author's collection.*

bags created a series of dolls printed on the insides of the sacks. Among those available were Uncle Sam, a Scotty dog, an Eskimo doll named Uluk and a Russian called Minka. Women with more bags than they could use were able to sell them back to the store of purchase, or they traded to get matching patterns.

To encourage the cloth bag industry, the National Cotton Council put out publications such as *Sew Easy with Cotton Bags and McCall Patterns, Cinderella Fashions From Cotton Bags* and *Bag Magic for Home Sewing*. There was even a contest—Sew Your Way to Fame & Fortune with Cotton Bags.

Since flourmills in Tacoma sprang into existence during the first years of the cloth sack, they were in the vanguard of the industry. The first mill here was the Watson & Bradley Company, built in 1885 at Twenty-Third and East D Streets. The Puget Sound Flouring Mill Plant at what is now Three Schuster Parkway followed in 1889. Kenworth Grain & Milling Company came along six years later, at Fifty-Sixth and Washington Streets, and the Sperry Flour Company was built in 1905. There were others, but Sperry was the biggie; in its heyday, Sperry shipped out bags of flour with over six hundred different labels.

When the United States entered World War II, using flour sacks was a way to conserve. By the 1950s, however, paper packaging started replacing cloth. Though the feed sack industry fought back by way of advertising campaigns and even a television special encouraging the use of feed sacks for sewing, the writing was on the bag. Now, it is mainly the Amish who want the old-fashioned cloth bags.

Depression Income: Frog Farms

During the Depression, needs boiled down to a place to live, food and clothes. Everything else, including electricity and running water, was the gravy. However, even the bare necessities required money, and to provide for the essentials, three Pierce County men decided the way to an income was through frog farming.

In October 1934, a *Tacoma Times* reporter interviewed Mr. Otto Richardt at his Silver Lake home, twenty-four miles from Tacoma on the Mountain Highway. The farm consisted of a 34-acre lake with 65 acres of shoreline. The lake was smack in the middle of 234 acres enclosed by a four-foot-tall wire fence with a four-inch strip of metal around the top.

Nine years earlier, someone started a muskrat farm there, hoping to take advantage of the fashion for fur coats. That person had spent $12,000 on the fencing and then stocked the area with two hundred muskrats. Every night, the would-be furrier fed the muskrats fourteen sacks of carrots, and at the end of four years, he harvested exactly forty-five muskrats. He decided to sell the lake, and another muskratter bought the farm. It was this farmer who sold the property to Richardt in 1932.

Richardt stocked the lake with ninety-six African Jumbos. "A frog," he said, "would lay from 18,000 to 20,000 eggs during the June spawning season," adding that they came into maturity in four years. All he had to do was to hang in there for a couple more years, at which time he felt he could harvest and sell the Jumbos for twenty-five cents apiece to local restaurants. In the meantime, he mounted the fence posts with predator traps and spent his nights patrolling the grounds and shooting any uninvited marauders.

Either word about money to be made from frogs got around, or the *Times* just loved a good frog farm story, because in July 1935, the paper had an article on A.E. Woodard's enterprise near Gig Harbor.

Woodard had been a cattle drover who left the "doggies" behind and bought land about eight miles southwest of Gig Harbor and a mile south of Horseshoe Lake, where he went to work creating a "dry-fly fisherman's paradise." The property had a spring, and the first thing Woodard did was dig a seven-acre trout pond for fishing and six smaller ponds for trout breeding. He stocked the pond with eastern brook trout, silver trout and cutthroats, and the "cuts" more or less took over. They averaged fifteen inches; the longest caught was twenty-two inches, and the fishermen frequently left the pond with strings of fish exceeding Mr. Woodard's five-foot limit.

In 1931, Woodard decided muskrats and frogs would thrive in his ponds and not bother the fish, so he brought them both in. His frogs were also Jumbos but were supposed to be Washington State natives. They came from a Thurston County breeder, had a twenty- to twenty-five-year lifespan and could jump approximately thirteen feet. Woodard posed for a newspaper photographer with a two-and-a-half-pound, seven-inch-long Jumbo. It wasn't the biggest frog on the farm, though; that fellow weighed in at five pounds. However, Woodard had no plans to sell the Jumbos for food; the frog skins were for women's slippers.

At the time of his interview, Woodard had just entered the market selling tadpoles and breeding stock. People from all over the country were writing for his advice on raising frogs both alone and in conjunction with other animals.

Two years later, the *Times* jumped on another frog farm story. This farm was in Steilacoom and being run by husband-and-wife team Mr. and Mrs. Charles Turner. Mr. Turner, a former Chicago cab driver, moved to Steilacoom but had, he explained, "Got bit by the frog-raising bug during a trip to California," when the owners of a California frog farm told him about the frog market and profits to be made. As soon as the Turners returned to Steilacoom, Mr. Turner dug four ponds and stocked them with what he called Leaping Lenas, aka Jumping Jimmies.

The Lenas immediately went to work laying egg spawn in clusters that floated sheet-like on top of the water. Each spawn varied in size from two

2. Ah, here they come! What are they, though? They look like pollywogs. They must be Tadpo icemen, who will later turn to frogs.

Cartoon of frogs. *From* Tacoma Daily News, *August 29, 1908.*

PLENTY OF CROAKERS
And now the Fairhaven cat ranch boomers are into another scheme. They propose to plant 900,000 frogs in a pond near there and in a year or two control the market.

—Tacoma Daily News, December 14, 1891

to four feet square. Turner said his eggs hatched into pinhead-sized pollywogs in three days. Once hatched, he and Mrs. Turner gathered the pollywogs up and put them in large wooden frames containing cheesecloth to prevent their "jumping away." "When the pollywogs got large enough to shift on their own," he said, "they were turned loose." Some of Turner's frogs had a twenty-six-inch spread when measured from head to webbed foot. After three years, from "wog to frog," they were expected to measure thirty to thirty-six inches, at which time he'd ship them to market.

The *Times* reporter also included the following interesting tidbit: tadpoles make good pets because their development into frogs could be arrested by keeping them in cold water and they never needed to be fed. Tired of having them around the house? Just heat up the water, let them develop and turn them loose. Also, when frogs reached marketable size, they could be frozen alive in cakes of ice and kept that way for months at a time. When thawed they would come back to life and hop around as if nothing had happened.

The Turners wanted to make their farm the frog capital of the state. No records remain of their success or that of the other two men.

DEPRESSION INCOME: ~~FLOWER~~ FLOUR POWER

Even when newspapers did have Society sections, pastries have never received a lot of press coverage. So when, on January 11, 1914, the *Tacoma Daily Ledger* had a front-page story about pastries, it was unusual.

According to the *Ledger*, Mr. and Mrs. Herman Stusser, who lived at 1418 South G Street, were getting ready to welcome home their son, Samuel, from the East. Six years earlier, Samuel left Tacoma and headed for the University of Illinois to study medicine. To celebrate his return, Mrs. Stusser started baking cakes, pies and cookies to welcome her son home. At three o'clock in the morning, after long, hot hours in the kitchen, she heard someone moving around on the bottom floor of her home and called the police. "A burglar's in my house. Come quick!" she shouted in the receiver. Three officers responded and, with guns drawn, tiptoed inside. A slight smell

of smoke led them toward the kitchen, where they saw the wisps coming through a keyhole in the pantry door. Yanking it open, they dove in. What they found was a man sleeping on some laundry piled on the floor. The burglar's name was John Casey, and when he heard about Mrs. Stusser's marathon cooking, he broke into the house. He took all the goodies off the shelves, sat on the floor and piled them around him. Then he started taking a bite or two out of everything she'd made. When he was full, he pulled out a pipe, lit it and snuggled down on the laundry. It's easy to fall sleep on a full stomach, and that is what happened. The pipe slipped from Casey's hand and started smoldering in the washing. Casey was arrested, and his court hearing was set for the next day. Unfortunately, the papers didn't cover it.

Mrs. Stusser wasn't alone in having food stolen right from under the cook's nose. For a time, homes on Tacoma's west side were "plagued with a peculiar class of hungry pilgrims." They pretended to be hoboes, knocking on doors and asking for food. If refused, they returned later and rifled bureaus and pantries. One of the thieves wandered into a west end house, found a pastry in the pantry and took it to the parlor to eat. The next morning, the family found crumbs scattered all over the carpet. That's when one unnamed homemaker decided to retaliate. She baked a pie that looked like any other pie—with one difference. She added "delectable drugs known to give gruesome results," i.e. diarrhea, and put the pie in a conspicuous place. The only surviving record of her endeavor is that the coroner had nothing "ill-toward" to report.

The next time a pastry story made news above the fold was in 1939, when a large picture of Mrs. Art Miller appeared. Mrs. Miller was developing a specialized pastry business.

Though the Depression was waning, starting a new business, especially for a sweet not everyone liked, was a bold move. Mrs. Miller was making and selling fruitcakes. Her brother gave her the idea when, in 1919, he said he'd like a fruitcake with neither raisins nor currants because they always seemed to be gritty. Which was no doubt true; consumers usually had to clean and pit them before use.

Until clean raisins came on the market, homemakers would lay out about five pounds on a clean surface and, if the raisins were damp, lightly flour them down. Next, they picked off the dry stalks and started the deseeding process. Some cookbooks recommended plumping them up with warm water and then using a sharp knife and cutting the seeds out, raisin by raisin. However, the lucky homemaker owned a deseeding device. Then all she had to do was clamp it onto the kitchen table, fill the hopper with raisins and start turning the handle. Two grooved rubber and toothed-metal rollers

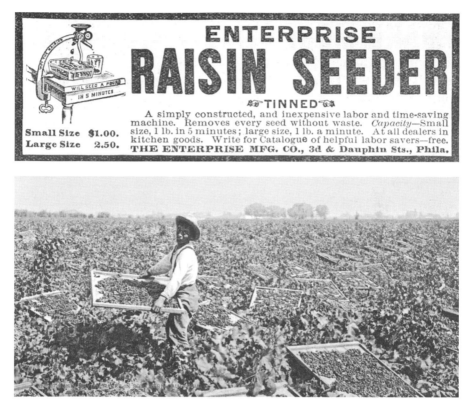

Top: An 1895 ad for the Enterprise Raisin Seeder. *Author's collection.*

Bottom: Raisin drying rack, postcard circa 1901. *Library of Congress, Prints & Photographs Division, Detroit Publishing Company Collection [LC-DIG-ppmsca-17962].*

squeezed the fruit and expelled the seeds and forced the raisins into a chute, out of which they dropped down into a pile. After that, it was a matter of putting the raisins in a sieve, rinsing them with hot water and packing them away when dry.

However, as Mrs. Miller told a *Tacoma News Tribune* reporter, "It was almost impossible to get ether raisins or currents [*sic*] clean." She started creating a recipe to replace them with candied cherries, pecans and dromedary dates. The binder ingredients were a secret she perfected, memorized, wrote down and locked away in a safety deposit box.

To get her business going, Mrs. Miller took an unorthodox route. She made a fruitcake, cut off slices, wrapped them up and mailed the slices to famous people around the country. Jean Hersholt was a recipient and became a fan. Hersholt is little remembered these days, but from 1937 to 1954 he was Dr.

> Favors at the ball held at the Scottish Rite Cathedral at Tacoma were slices from a ninety pound fruitcake whose five tiers rose more than three feet high.
>
> —*Bellingham Herald*, January 31, 1934

John Luke on the CBS radio soap opera *Dr. Christian*. He also appeared with Shirley Temple in the 1937 version of *Heidi*.

Irene Rich, another mostly forgotten actress, carried on an extensive correspondence with Mrs. Miller when her (Rich's) slice of cake was lost. In the 1930s and 1940s, Rich was a busy character actress. She was in eight of Will Rogers's movies, acted with John Wayne in *Angel and the Badman* and was in John Ford's *Fort Apache*. In addition, she hosted a radio anthology program, *The Irene Rich Show*, for over ten years. Mrs. Rich's lost cake was mailed in December 1938. The delivery company Mrs. Miller used told her to send a second one and they would look for the first one. Ultimately, the actress received both slices.

Mrs. Miller's most famous recipient and fan was Mrs. Eleanor Roosevelt. The president's wife had been visiting a daughter in Seattle and was either served or just made aware of Mrs. Miller's cottage-industry fruitcake. At any rate, she liked it so much she made note of Mrs. Miller's address and several months later wrote her requesting five two-pound cakes.

During the 1938 holiday season, Mrs. Miller had orders for three hundred pounds of cake and decided she'd better patent the recipe. Months later, she was still fighting with the patent office because, she said, "the patent office employees didn't know anything about fruitcake."

In the meantime, she was baking up a storm, shipping to South Carolina, New York, Los Angeles, Sitka, Ketchikan and other places. Sadly, how many years she continued working and what happened to or who inherited the recipe isn't known.

In 1956, Truman Capote wrote "A Christmas Memory." Part of the story tells of helping his cousin, Miss Sook Faulk, make fruitcakes when he was a child. Truman and Sook also sent them to the Roosevelts. This would have been at about the same time that Mrs. Miller sent hers.

> A cake-eating burglar, who only got $4.50 in Canadian coins, had his impromptu meal interrupted at 12:30 a.m. Sunday when Mr. and Mrs. Delbert J. Williams, 3717 South Ainsworth Avenue returned home. They think the burglar gulped a final bite of cake and left through the kitchen window.
>
> —*Tacoma News Tribune*, April 26, 1948

The Depression-Mobile, Kitcheneering and More Homeless Men

When times are tough, as they were during the Depression, people naturally try to find ways to make their lives better. That is what a Lakeview barber did when he built the Depression-Mobile, which he unfortunately unveiled too late for the 1933 Tacoma Automobile Show.

R. Slyter, who designed and built the machine, wanted something he could use to get around the neighborhood when he sharpened tools. To make it, he got hold of three Ford wheels, some lumber and three-quarter-inch pipe. He then built the machine along the lines of a railroad speeder, also known as a draisine—a light auxiliary vehicle, such as a handcar, used by railroad service crews to take men and materials to wherever needed for maintenance. Mr. Slyter's vehicle had room in the back for his grinding machine, a seat and a top to keep him dry. He installed a lantern in front, a stoplight in the rear and a rearview mirror and painted the whole thing bright red. It went from four to eight miles an hour, depending on the grade, because it was pedal-powered.

While Mr. Slyter was grinning every time he passed a gas station, the local Safeway Stores were involved in low-budget cooking schools.

At the time, Safeway employed at its Oakland, California location a member of the Bureau of Home Economics: Miss Marian Spencer. Spencer had a degree in household science and was experienced in what was called the commercial field of home economics. Much of her information would have come from Miss Ruth Van Deman of the Bureau of Home Economics. Miss Van Deman and Mr. Wallace Kadderly were part of the Office of Information, one of the lesser-known agencies under President Roosevelt's National Recovery Act. They made radio broadcasts in conjunction with the Department of Agriculture on the *National Farm and Home Hour* aired by NBC radio on its ninety-three affiliated stations

The Home Makers Bureau was very concerned with people, particularly children, having access to a proper diet. As a result, agency members handed out pamphlets about food preparation and stretching what provisions families had. Along with the recipes, the agencies also gave out salt pork, flour, milk and vegetables—amounts depending on the numbers of family members. One recipe the bureau recommended was salt pork and whole meal hash. To make it, cooks were told to boil whole wheat until tender and cook the salt pork in water, changing the water several times if the meat was particularly salty; chop it into small pieces and fry onions in some of the fat; and mix equal

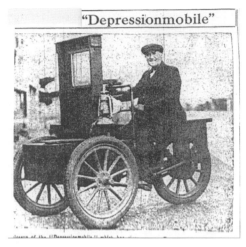

"Depressionmobile"

AUNT SAMMY'S
RADIO RECIPES REVISED

COMPLIMENTS OF
YOUR CONGRESSMAN
THOMAS D'ALESANDRO, JR.

BUREAU OF HOME
U.S. DEPARTMENT OF
ECONOMICS
AGRICULTURE

Above: Mr. Slyter's Depression-Mobile. *Author's collection.*

Right: Cover of *Aunt Sammy's Radio Recipes Revised*. *Author's collection.*

amounts of the whole wheat and meat and a chopped green pepper and/or carrot if available and if family members liked them. Corned beef could replace the salt pork, and rice or hominy could replace the whole wheat.

However, getting back to Spencer, she was conducting the Safeway Stores Cooking School—a program called Kitcheneering—at the First Baptist Church. Emphasis was on obtaining nutrition at the lowest cost.

While Mr. Slyter was making the Depression-Mobile and Miss Spencer conducting cooking classes, Detectives Black and Blacksmith, Sergeant Lyons and Officers Nelson, Marshall, Morrison and Schnugger were raiding jungle camps.

A general opinion of the time was that many discharged veterans from World War I had begun hopping freight trains looking for work. When the Northern Pacific Railroad opened up Washington Territory, some of these disenfranchised men followed the rails west. Old newspapers are full of articles about cities driving floaters, as they were called, out of town. Also, during elections, Seattle had a habit of flooding towns—Tacoma, in particular—with floaters. They managed to establish some sort of residence and then voted the way they were told. However, the Depression created a different kind of homeless man. Unlike bums, hoboes would work, but during the Depression, jobs were scarce and then, as now, many men didn't want to live in shelters.

A related government entity that Miss Van Deman was involved in was the accuracy of household measuring cups. She wrote *A Guide to Good Meals for the Junior Homemaker and Aunt Sammy's Radio Recipes*. Demand for *Radio Recipes* was so great that it had to be reprinted after only a month. The cookbook was revised and enlarged three times and was the first cookbook produced in braille.

On February 23, 1933, sixty-five men living in shacks under the old and new Puyallup bridges were arrested. Armed police officers formed cordons around the encampments. Police cars and patrol wagons took the men to the station, where they were fingerprinted by the Bureau of Records. Some of the men had warrants, but others were just down on their luck. They were let go but told to leave town.

In November 1934, a *Tacoma Times* reporter named Bill Hipple dressed as a hobo and went undercover to report on life as a Depression-era homeless transient in Tacoma. Hipple was an interesting character. In Tacoma, he "traded baseball tickets for haircuts and tuxedoes in order to crash social events to which he wasn't invited." From Tacoma, he went to work for the United Press and the Trans-Radio Press and was sent to the East Coast. Tiring of regular work, he "flagged passage on a liner to Cuba." With fifty dollars, nonexistent credit and a borrowed tux, he posed as a rum buyer. When the truth caught up with him, he was given one Cuban dollar and thrown off the island.

However, during his thirteen hours as an undercover bum in Tacoma, he went to the WERA shelter #1 at 1901 Jefferson Avenue and was given food and a place to sleep. Approximately four hundred other destitute men joined him. Most of whom, he said, wanted work, not soup kitchens. They ate in shifts of ninety-six at a time and, when the shelter ran out of beds, slept on the tables and the floor using newspapers as blankets.

Hipple went on to serve as a war correspondent, interviewing General Douglas MacArthur and Admiral Chester Nimitz. His obituary says it was he who suggested to Associated Press colleague photographer Joe Rosenthal that worn-out marines raising a flag on Mount Suribachi would make a good photograph.

And as for the homeless and destitute, the war gave those who wanted them jobs.

And the Things They Left Behind

There's a picture on the web of artifacts from the original Fort Nisqually, which was excavated when the buildings were moved to Point Defiance Park in 1934. It stands to reason that things unearthed as pioneers moved west and cleared the land were often either Indian or military. Perhaps "military" explains a demijohn of whiskey John Waughop found about a mile east of the Steilacoom Hospital in 1892. A man living in the area said that in 1859 someone broke into the Fort Steilacoom commissary and stole some whiskey. If the demijohn was part of the theft, it must have been under "the wide-spreading fir tree" where Dr. Waughop found it for twenty-three years.

There are few newspaper articles about items discovered in the Tacoma area in the nineteenth century, but in 1896, when some skeletons and a large building were unearthed near Anderson Island, a *Tacoma Daily News* reporter assumed that because the building was large, Puget Sound must have, at one time, been populated by Amazons.

A few years later, Thomas Eggers, proprietor of the American Fish Company (address unknown), dug up four skeletons, a flintlock and some other unnamed artifacts, which led him to believe he'd found an Indian grave. In 1909, six more skeletons were found in shallow graves on the tide flats. Also, men working under the commercial dock between Fourth and Fifth Streets on Dock Street found a cache of lead pencils, lamp globes, lanterns, pocketbooks and a French horn.

Men working for the Northern Pacific Railroad on a small, dry knoll near the railroad tracks by Lincoln Avenue found the remains of an old chest containing parts of two old guns, beads, brass buttons and coins. One of the coins dated to 1862.

In the early twentieth century, three archeological expeditions came west: a group from the Smithsonian came in 1920 but focused on the Columbia River. They were followed by a team from the University of California, which also concentrated on the banks of the Columbia but went on to excavate the area between the mouth of the Deschutes River and The Dalles. The most active period of archeology in Washington began in 1946 when the River Basins Survey Project—supported by the Smithsonian, the Bureau of Reclamation and the National Park Services—was organized. The survey project was responsible for salvaging archeological and paleontological materials in reservoir areas prior to dam construction. Most finds, though, were strictly by accident.

In 1926, Stadium High School student Elvira Zsigmondovics went looking for her tennis ball in a vacant lot near North Thirty-Seventh and Union

Streets and found a pottery pipe. It had an intricately carved bowl in the shape of a chieftain's head, with three large feathers attached. William Bonney, curator of the Ferry Museum at the time, felt the pipe was likely of Aztec origin. "Archeologists," he said, "were coming to the conclusion that an Aztec civilization thrived in the Pacific Northwest before relocating to Mexico."

George A. Marvin was digging in the backyard of his Day Island home when he found yet another skeleton. This one was lying facing up, and Mr. Marvin described it as being "slant-browed, heavy of jaw, and with beetling frontal ridges over the eyes. The front teeth," he said, "met squarely like those of a monkey or ape." The skull had a bad fracture above the right ear.

In late March 1939, a boy named Jimmy was warned that he had to license his police dog, Lobo, and that he had only three days in which to do so. Jimmy and Lobo, who lived at 1108 North Union, took a walk to think the situation over. Suddenly, Lobo broke away from Jimmy and started digging a hole. For a minute or two, dirt flew, and then out came a silver dollar. Jimmy was thrilled and ran home to show his mother. She thought it was some sort of trick and suggested he go back and see if there were any more coins. Back Jimmy and Lobo went, and Lobo began digging in the same hole. Once again, dirt flew, and once again a silver coin came out. When Jimmy returned home, his dad got excited. He went to the hole and dug up a third silver dollar, plus a half-dollar coin. The dollars carried the mint year of 1888, and one had rust on it as if it had once been in a rusty can. According to the newspaper, a lot of silver dollars had been minted in 1888. Jimmy had enough money to license Lobo and get her a rabies shot.

On April 5, 1933, President Franklin Delano Roosevelt signed Executive Order 6102 "forbidding the hoarding of gold coin, gold bullion, and gold certificates within the continental United States." It was an unhappy action for twelve-year-old Howard Hanson, who, in September 1933, found a cache of gold under a Puyallup house. Howard had been chasing a rabbit and followed it under a home belonging to Mr. and Mrs. A.V. Nelson. There he found two sacks and a container with $9,000, gold coins, securities and jewelry worth more than $15,000 inside. He kept $100 and divided the rest with three friends. Pretty soon, they were sick of movies and had a lot of stomachaches from too much candy, and their spending was making people talk. Police chief Frank Chadwick went to have a little talk with the boys, who were subsequently arrested. The cash, they said, totaled around $7,500, but they burned "the old papers."

The Nelsons had been out of town when the discovery hit the papers, and Mrs. Nelson fainted when she learned of the fire. While the cache was in police possession, Officer Mark Snow "diverted $130 to his own use." In the

meantime, E.M. Burkette, guardian of two of the boys, claimed the money on their behalf and asked the police for an accounting of the cash, and the two boys became defendants in a lawsuit brought by the Nelsons. Six months later, the court found on behalf of the Nelsons. However, the government stepped in and claimed $575 for the gold coins and was expected to do the same for the gold certificates. The Nelsons were also ordered to pay the court costs. Officer Snow resigned, repaid the money and received a suspended sentence of one to four years in the penitentiary.

A find in 1954 on North Thirty-Fourth Street was particularly unusual. While digging a basement, an unnamed man uncovered a copper axe head. Dr. Frederick McMillan, head of the "College" of Puget Sound, said it was "primitively made, with a heart-shaped design and construction of the eye for the handle." Both sides of the surface, he said, "are decorated with the heart design that stands in relief." He said it was possibly of pre-Indian origin.

For a while, unusual items popped up all over Puget Sound: sea shells imbedded in soft rock in Eatonville; a Roman coin in a shale bank on the Solduc River; the petrified remains of several bones and two large teeth in Seattle; giant bird tracks 1,500 feet down in a Black Diamond coal mine; a mastodon tooth at Hoquiam; a lead cannon ball in Montesano; and another cache of gold, this one at Alderton. One of the most unusual finds was a Civil War diary.

When Mrs. Eva Hobart went to see what a man had dumped along some Commencement Bay railroad tracks, she found a diary written by Sergeant George H. Boardman of Company F, Twenty-second Regiment, Bangor, Maine. In it he wrote of "Our brave and good Col. Jerrard dishonorably discharged for an alleged disobedience of orders which were issued by a drunken colonel commanding the brigade by the name of J.S. Morgan, 90th New York volunteers." She gave the diary to Mrs. William O. Causin, niece of President Dwight D. Eisenhower.

However, perhaps the most poignant find of all was a child's sampler. In 1938, a man tearing down some old buildings on the Roy prairie found it in a barn along with some other items. The property had been part of the original Chambers homestead, and the items were in an attic storage place. The sampler was done in shades of green, brown, rose and blue and had clusters of roses in the upper corners, an eagle in one lower corner and an unidentified item in the other. In addition to the alphabet, the sampler had the numbers one through ten and the legend "Mary Jane Chambers Sampler Worded A.D. 1846, Oregon Territory Molally Co."

All of these artifacts are part of Tacoma's history.

BIBLIOGRAPHY

Blackwell, Alice. *Reminiscences of Tacoma*. Tacoma, WA: Tacoma Public Library, 1911.

Blackwell, Ruby Chapin. *A Girl in Washington Territory*. Tacoma: Washington State Historical Society, July 10, 1973.

Curran, Sally. *Prohibition in Tacoma: Sixteen Misguided Years*. History Seminar 400, Martha Lance, May 16, 1997.

History of Pierce County. Vols. 1 and 3. N.p.: Heritage League of Pierce County, 1990, 1992.

Hunt, Herbert. *History of Tacoma*. Chicago: S.J. Clarke, 1916.

Lundberg, George A. *Child Life in Tacoma: A Child Welfare Survey*. Tacoma: Department of Sociology, University of Washington, August 1926.

More Than a Century of Service: The History of the Tacoma and Southern Sound. Seattle: University of Washington Press, 1979.

Morgan, Murray. *Puget's Sound: A Narrative of Early Tacoma and the Southern Sound*. Seattle: University of Washington Press, 1979.

Reese, Gary Fuller. *Did it Really Happen in Tacoma? A Collection of Vignettes of Local History*. Tacoma, WA: Tacoma Public Library, 1975.

Ripley, Thomas. *Green Timber*. New York: American West Publishing Company, 1968.

Newspapers

Kansas City Star
Los Angeles Times
News Tribune
Seattle Times
Senior Scene
Tacoma Daily
Tacoma Daily Ledger
Tacoma Daily News
Tacoma Herald
Tacoma Times

Internet References

www.biodiversitylibrary.org
www.bohttps://recipereminiscing.files.wordpress.com
www.cityoftacoma.org
www.ehow.com/how_8744716_do-clean-raisins
www.govbooktalk.gpo.gov/
www.hebervalleyquilters.com/resources/HvQ%2010-11-2011%20PP.pdf
www.historylink.org
www.iwm.org.uk/history/5-facts-about-camouflage-in-the-first-world-war
www.mequiltshoppe.com/history-of-the-1930s-feedsack-fabric.htm
www.recipereminiscing.files.wordpress.com
www.tacomalibrary.org
www.us.bureauveritas.com

ABOUT THE AUTHOR

Karla Stover graduated from the University of Washington with honors in history. Locally, her credits include the *Tacoma News Tribune*, the *Tacoma Weekly*, the *Tacoma Reporter* and the *Puget Sound Business Journal*, and she discusses local history on KLAY-AM 1180 weekly. She is a member of the Tacoma Historical Society and the Daughters of the American Revolution. In addition, she writes a monthly column for *Country Pleasures* magazine.